SO-BNJ-031

# OBSERVATIONS

*Edited by David Featherstone*

*Contributors*

Maria Morris Hambourg

Bill Jay

William S. Johnson

Mark Johnstone

Estelle Jussim

Max Kozloff

Beaumont Newhall

Alan Trachtenberg

Anne Wilkes Tucker

*Untitled 35* • *The Friends of Photography*

© 1984, The Friends of Photography
The authors retain copyright in the individual essays.

All rights reserved in all countries. No part of this book may be reproduced or translated
in any form without written permission from The Friends of Photography.

ISSN 0163-7916; ISBN 0-933286-39-2
Library of Congress Catalogue No. 84-80869

Untitled 35: This volume is the thirty-fifth in a series of publications on serious photography
by The Friends of Photography. Some previous issues are still available.

Designed by Peter A. Andersen

# TABLE OF CONTENTS

ACKNOWLEDGEMENTS

Imagine fully understanding the layered message of a single photograph, much less the whole genre of documentary photography or a body of work within it. Beyond the superficial and descriptive, meaning in photography is elusive, but it can be enhanced by the knowledge and experience of others. This book uses words to broaden our understanding of documentary photography, words that not only increase our perceptions, but give us an extended dimension for future understanding.

Production of this book would not have been possible without the support of a grant from the Visual Arts Program of the National Endowment for the Arts. Their concern that this book be published is most welcome. I would like to express my thanks to the nine authors included, who not only produced a fine collection of essays, but who were able to adjust their schedules in order to meet our deadlines.

Grateful acknowledgement also goes to David Featherstone, whose skillful editing of the essays has made the writing all the more concise, and to Peter A. Andersen, who created the handsome design for the book. Thanks is also offered to Claire V.C. Peeps, Julia K. Nelson and John Breeden, for their editorial assistance; and to Pam Feld and Janet Dahle, for their assistance in preparing the manuscripts.

James Alinder, Editor
The *Untitled* Series

# PREFACE

The concept of documentation is inherent in the nature of the photographic process. That is, the camera makes a record of the "event" within its field of view at the instant of exposure. The vast majority of the images made in the first half-century of the medium's history can be seen, in these terms, as documentary. As photographers began to explore more subjective avenues of expression, and to utilize photographic documentation in a personal visualization of the world, the term *documentary* came to refer to photographs made from a specifically humanistic point of view. These photographs of human activities, and of situations affecting the human condition, initially found broader importance in the early part of the twentieth century, when they began to be used in the public service—for example, as evidence that brought about the development of child-labor laws. Documentary photographs came to the attention of an even wider audience with the advent of picture magazines in the 1930s; the picture-story form evolved during the next two decades into a sophisticated visual and humanistic presentation. Documentary photography has clearly become a major concern of twentieth-century camerawork; it continues to be a vital—and at times manipulative or misleading—force in contemporary culture.

Perhaps because of the close relationship between the documentary photograph and the written word—a caption or other textual information has traditionally accompanied images of this kind—there has always been a great amount of writing produced in concert with it. A bibliography published in 1983, for instance, of articles and books written during the past five decades dealing with the Farm Security Administration photography project alone, contained more than a thousand entries. Serious interest in documentary photography remains high among critics and historians, and the concept of the documentary image has received increasing consideration in symposia, conferences and lectures held in many parts of the country.

A number of artists who previously had been concerned with what might be termed "formal" approaches to the medium have recently found new visual interest in the documentary image, and have developed an increasingly dynamic and subjective response to documentary situations and a more socially-conscious imagery. The orientation of many of these photographers to exhibiting rather than publishing their work has brought humanistic photography to a larger museum and gallery audience, providing a greater fine-art context for a kind of photography that has traditionally established its importance through human rather than aesthetic values.

Despite the demise of picture magazines such as *Life, Look* and *Saturday Evening Post* in the late 1960s and early 1970s, activity by photojournalists and other documentary photographers has remained high as new outlets for socially-conscious imagery have developed during the past decade. This ongoing and widespread interest in documentary photography has led to a reconsideration by many writers of the context and motivations of early documentary photography and to an extensive discussion of newer work in the field. The concept for *Observations* emerged from this healthy milieu.

The articles presented in this issue of *Untitled,* have been written specifically for publication here. At the beginning of the project, a call for abstracts was sent to a large number of critics and historians. Some thirty individuals responded with proposals for essays. The nine published here were selected for the importance of the critical ideas they contained, and for their diversity of subject matter. While each essay implicitly confronts the changing definition of documentary photography, it is not the purpose of this book to determine specific parameters for a critical consideration of the medium. Rather, it has been assumed that the term *documentary* can be broadly conceived in order to allow a more complex interchange of ideas to develop between the different essays.

David Featherstone, Editor
*Observations*

# A BACKWARD GLANCE AT DOCUMENTARY

*Beaumont Newhall*

Documentary Photography is a term that has defied definition ever since it was first introduced in the 1930s. It is analogous to, and perhaps inspired by, the school of documentary film-makers in Great Britain headed by John Grierson, who used *documentary* to describe films made of what he called "actuality" or "the real world," as opposed to the artificiality of Hollywood's contrived photoplays, which used studio sets and employed professional actors and actresses. He urged filmmakers to take their cameras on location and photograph the environment itself, not its replica; its inhabitants, not "stand-ins." But over and above this simple distinction, he stressed the need for the dramatization of the "real" by using the cinematic medium in an expressive way. He wrote, "We believe that the cinema's capacity for getting around, for observing and selecting from life itself, can be exploited in a new and vital art form."[1]

This subjective aesthetic criterion, which Grierson called "dramatization of fact," sets the documentary film apart from the more objective and passive newsreel.

In the older field of still photography the situation is somewhat more complicated, because the overwhelming majority of photographs are taken "on location," and do, in fact, visually record the "real world." One of the earliest definitions of the documentary aspect of still photography was made by Ansel Adams in his seminal book *Making a Photograph* (1935).[2] In the final chapter, "Types of Photographs," he writes, "The type of photography which interprets the social scene in the way

of commentary is adequately described by the term 'photo-document.' Two broad classifications may be established. One treats of the individual, singly or in mass, in relation to contemporary civilization and social conditions." Adams illustrates this class with a reproduction of Dorothea Lange's now famous *Bread-line,* 1933. In his second classification, the photo-document "records the material evidence of culture, architecture, art and other forms of expression and fabrication, also in terms of commentary. The photo-document is always *dated;* the first classification is obviously contemporary, the second may reveal both contemporary aspect and an implication of the period which fostered it." This he illustrated with his own photograph, *At Sutro Gardens, San Francisco,* a mediocre sculptural pastiche of a draped female figure in antique style seen against the broad expanse of the Pacific Ocean. His commentary: "The emotional impact of this picture lies in the juxtaposition of a definitely dated element and a timeless naturalistic one *plus* satirical connotations of a sufficiently remote period of culture."

This division of documentary into social and historial commentary was also made by me in my article in the periodical *Parnassus* (March, 1938); and by Berenice Abbott, an avowedly and highly gifted documentary photographer, in her *Guide to Better Photography* (New York, 1941).

I now feel that *documentary* is hardly the adjective to qualify such photographs as Henri Le Secq's pictures of medieval cathedrals, Charles Marville's views of old Paris or O'Sullivan's landscapes of the American Southwest. It seems to me quite clear—and certainly it appears clear to my fellow contributors to this volume—that a far more appropriate term for most of the work done under the name *documentary* can best be described less categorically and more accurately as being concerned with the human condition or, in a word, *humanistic.*

One of the puzzling things about *documentary* is that it has been used so often in an exclusive, categorical way. The extraordinary photographic work done between 1935 and 1943 by the Historical Section of the United States Government's Farm Security Administration is considered the classical documentation of the depression era. But one may well ask what photographs of the urban scene, of civic monuments, of shop windows, of automobile junkyards and Mississippi riverboats have

to do with those agricultural problems that the FSA was set up to investigate and solve? On the other hand, I have never seen the brilliant *Life* photo essays by W. Eugene Smith—of life in a Spanish village, of the country doctor, of the nurse midwife—classified as *documentary*, although they certainly belong to that category.

No one thinks of Alfred Stieglitz as a "documentarian"; he would snort at the thought. Yet his 1907 photograph *The Steerage* is in every sense a document of a highly important aspect of American culture, a biting comment on immigration in general, then at its height, and emigration in particular; the return of foreigners from America to their homelands. Why have we overlooked, in our category of *documentary*, the candid photographs by Erich Salomon of European diplomats in deep deliberations of subsequent world importance? Or the photographs of street markets of London and of Eton College by the abstract painter/photographer Laszlo Moholy-Nagy? While we accept Henri Cartier-Bresson's *Le Retour* as an exemplary documentary film, we are disinclined to view his total work in that category.

Conversely, many fine art photographers are placed in the documentary category despite the curious fact that the leaders of that movement renounced aesthetic ideals. John Grierson, after stating that the first principle of documentary film was to produce "a new and vital art form," contradicted himself by stating that "documentary was from the beginning an anti-aesthetic movement."[3] Paul Strand once told me that on his return from a visit to Russia in 1935 he visited the documentary film producer Paul Rotha in London. He had brought a portfolio of his photographs to show Rotha, but to his surprise and disappointment, the filmmaker refused to look at them. Strand recollected that Rotha told him, "we have no interest in art."

Although the FSA employed some of the finest artist photographers, Roy Stryker, chief of the photographic project, had little patience with aesthetic qualities. When I was curator of photography at The Museum of Modern Art in New York, I proudly showed Stryker a superb set of prints made by Ansel Adams of some of Dorothea Lange's best negatives. They were beautifully mounted on museum board, with each carefully signed by both artists. To my surprise, Stryker burst into a rage of vociferous deprecation. The print quality was to him elitist, unfair to his

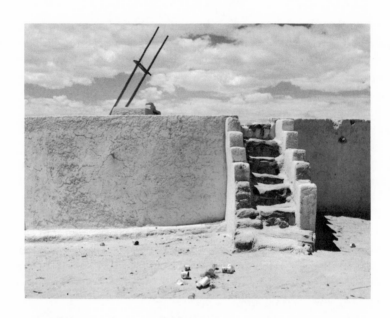

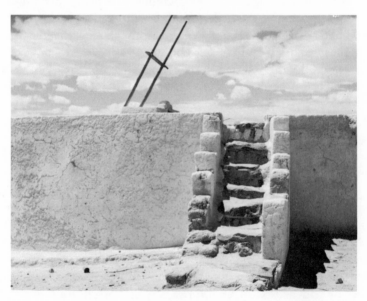

Photographs by Dorothea Lange. *Pueblo Kiva*, not dated. Collection of the author.

printer. He wanted to give the museum a pile of eleven-by-fourteen glossy prints for visitors to look at. "And when they become dog eared and worn out," he said, "I'll send you another batch."

It seems to me that photography only becomes documentary when it is documented. Infrequently the photograph itself contains its own documentation, as in one of the FSA photographs of Washington, which shows, in the foreground, pathetic slum housing conditions and, in plain sight behind, the proud Capitol of the United States. Sometimes this documentation is conveyed by words that appear within the image, as in the photograph by Lange *Near Los Angeles, California* (1939) that shows two migrants walking on the highway beside which is a gigantic billboard with the slogan "Next Time Try The Train—Relax." Or the documentation can be given by a short title, such as *Migrant Mother*.

Shortly before her death in 1969, Dorothea Lange sent me two prints of the same subject, the kiva of a Southwestern pueblo, with the question "which one is documentary?" My wife Nancy, our friend Peter C. Bunnell and I spent an evening trying to answer Dorothea's simple question. One photograph showed simply the wall and stairs of the kiva. This we called "the plain one." The other, almost identical, included some tin cans strewn at the front of the stairs. This we called "the tin can one." We wrote Dorothea that we thought the "tin can one" was the better photograph of the two. Even the clouds seemed better disposed, and the light on the wall more subtle. We guessed that it was Dorothea's favorite of the two. We considered that without a caption neither photograph could be considered "documentary." If the date of the building of the adobe were known, then the plain one could be considered a document of a culture at that period of time. We would need to know more about the tin cans in the second photograph. Were they dropped there by tourists? Then the picture could be considered evidence of the intrusion of one culture upon another. Or by Indians? Then a quite different conclusion could be drawn, one of changing customs of the pueblo's inhabitants. We asked Dorothea, "Which photograph did you take first?" Alas we never learned Dorothea's own answer to her question, since she died only two months later.

Documentary seems to me a matter of intent, not only on the part of the photographer, but of the viewer as well. It is as much a matter of how the picture is used as how it is taken.

NOTES

1. *Grierson on Documentary*, ed. by Forsyth Hardy (London: Collins, 1946), p. 79.
2. *London: The Studio Limited*, 1935.
3. *Grierson on Documentary*, p. 179.

# THE PHOTOGRAPHER AS AGGRESSOR

*Bill Jay*

O ne of the most widely and attentively read photographic books in recent years was the 1973 collection of essays by Susan Sontag, *On Photography.*[1] This book was not fiction, but a series of musings by the iconoclastic Sontag on the meaning and effects of a plethora of photographs in our culture. Following its publication there was a remarkable outpouring of concern—comments, criticism, academic debate and readers' correspondence—on a scale unprecedented in the history of photography for a book of words, as opposed to one of pictures.

Sontag made photographers uneasy and defensive, for many reasons. One of the prime causes of so much jittery concern, however, was Sontag's insistence that taking photographs was an aggressive/sexual act. She says, "There is an aggression implicit in every use of a camera." "It (photography) is mainly a social rite, a defense against anxiety, and a tool of power." "To photograph people is to violate them." "Like guns and cars, cameras are fantasy machines whose use is addictive." "To photograph someone is sublimated murder," and so on. Words like intrusion, trespass, exploit, violate, devalue and tool of power are liberally sprinkled throughout her photographic essays.[2]

It is interesting and curious that these remarks by Sontag should have been so provocative, because the most dominant characteristic of the photographer since the 1880s has been his aggression. This might be difficult for photographers themselves to accept—especially when any reader can name several friends who are gentle, contemplative types. But

the fact remains that the single most consistent attribute of the twentieth century photographer is his willingness, and even desire, to violate any and all social conventions of good behavior in order to take a picture. This image of the photographer/aggressor is inescapable in the fictional characters of photographers in short stories and novels; it is the most dominant theme in fiction that deals, however cursorily, with photography.

The origins of this attitude are not difficult to find, although they have been ignored by all historians. It is therefore worthwhile to examine the beginnings of the public's disenchantment with photographers, because it is in these historical events that the photographer/aggressor was created.

Photography in general received "good press" throughout the wet-plate era, from the early 1850s to the 1880s. The profession was considered an honorable one; it was useful, enjoyable and educational. Its application to both the arts and the sciences was growing, and its public image was held in high esteem. A growing number of well-bred women was entering the profession that was renowned for its lack of sexual discrimination, its rewarding of social skills and its encouragement of the Victorian virtues of patience, tact and enterprise. The photographic press consistently upheld the respectability of the profession and berated those individuals, or those aspects of the trade, not consistent with good manners and a sense of social responsibility.

This image of respectability was quickly lost, however, never to be recovered, with the advent of the dry-plate and hand camera. In all the essays and books on the history of photography in which the introduction of the hand camera is extolled, the general distaste directed towards the snapshot is rarely, if ever, mentioned. The writers might point out that the hand camera was scorned by most serious photographers; they do not point out that it was almost universally criticized by every intelligent non-photographer as a major social nuisance. They might discuss the large numbers of amateurs who entered the medium for the first time; they do not reveal that these snapshooters were generally derided as camera "fiends." They occasionally mention the competition for already dwindling markets between the professional and the amateur; they do not pursue the idea that the late nineteenth-century amateur brought

photography into such disrepute that it has taken nearly one hundred years for the status of the medium to recover.

But *what* was it exactly to which people objected in snapshot photography that they had not opposed with earlier processes? The answer is straightforward: *for the first time people could be photographed surreptitiously.* Of course clandestine pictures had been made with wet-plates (notably in the case of photographs of uncooperative prisoners), but these had been exceptions that necessitated a great deal of prior planning. With the snapshot camera, anyone at any time could be the victim of an embarrassing or even incriminating picture. It is sad to relate that the snapshot photographer knew and capitalized on this fact, and it became the rage to capture unposed people in awkward situations. The layman feared and hated the amateur with his ubiquitous camera, and the snapshooters ignored the restraints of common decency and good manners. The problem rapidly reached such proportion that, for the first time, the act of taking—or not taking—a picture was less an aesthetic consideration and more a moral or ethical one. All the endless debates about the photojournalist and his integrity (or lack of it) during the twentieth century have their roots in the uninhibited and unconstrained actions of the amateur of the 1880s. It is worth repeating for emphasis that, contrary to popular assumption, the snapshot photographer was loathed by the vast majority of right-thinking citizens during the final decades of the nineteenth century. Why this fact has been ignored or overlooked is difficult to understand, because a plethora of articles, news items, diatribes and irate correspondence is evident from even a cursory scanning of late Victorian publications.

The origins of the photographer/aggressor are well illustrated by this early incident reported from the seaside resort of Broadstairs in 1881. It has all the ingredients of the problem in one succinct paragraph. Several young ladies were enjoying themselves in the sea when a young man "with the inevitable camera" came along. A large wave struck the bathers and spun one of them around until, breathless but laughing, she was flung on the sand. The force of the wave had pushed the strap of her costume off her shoulder, and just as she noticed it and hurridly replaced the strap, she heard the click of the camera and saw the man's grin. The

girl jumped up from the water and, without saying a word, snatched the camera and flung it out to sea.[3]

This is the classic confrontation between a member of the public and the snapshot enthusiast that would be repeated hundreds of times in the succeeding years, and is therefore worth analyzing. First, such a picture could never have been attempted just a few years earlier. The collodion process would have necessitated the setting up of a darkroom tent and the coating of a glass plate prior to the exposure; the presence of this bulky darkroom and the activities of the photographer would have been clearly evident to a prospective "sitter." In addition, the exposure times would have been so long (commonly 10 seconds) that the active cooperation of the sitter in staying still for this time would have been essential. The subject would have had to be a willing and active cooperator in the production of the picture.

But with dry plates and instantaneous exposures, this photographer could make a picture without the agreement or participation of the subject. He was now an intruder. Perhaps the most important element in the story is that the girl heard the click of the camera and *saw the man grin*. He was satisfied that he had taken the shot at the expense of the unwilling subject, that he had triumphed at the cost of her embarrassment. If he had immediately seen her annoyance, quickly apologized and offered her the offending plate, no doubt the story would have had a happier ending and been a salutory lesson to the photographer on future occasions. But no—the lady stiffened into a pose of righteous indignation, and the photographer alienated himself with his self-satisfied smirk. In this circumstance the legal rights are irrelevant. The photographer's act prompted hate and violence. When such instances are multiplied by the thousands, it is not difficult to understand why the amateur photographer was a social outcast.

The problem was as acute in America as in Europe. In 1884 the *New York Times* featured a story on "The Camera Epidemic,"[4] in which it likened the snapshot craze with an outbreak of cholera that had become a "national scourge." Even people in perfect health, it said, are constantly harrassed by those who have contracted the camera disease. No one can walk down the street or sit down in the woods with a young lady without a dozen or fifteen cameras trained on them by "camera

lunatics" concealed somewhere close by. Another article in the same newspaper took up the theme of the "lunatics" and asserted that "it has not occurred to a single medical man that the first noticeable increase in the percentage of lunatics in this country and in England took place about a year after the introduction of dry plate photography. ... We need search no further to find out why our lunatic asylums are crowded."[5]

These and other facetious articles in prominent newspapers of the period serve as a reminder of the widespread distaste for the amateur photographer. The situation was not helped by the growing number of blackmail cases involving snapshots,[6] with curates and prominent society people as the prime targets.[7] In fact, actresses were always fair game for the snapshot photographer. *The Amateur Photographer,* the organ of the hand camera worker, wrote that "we must especially regret that Mdme. Sarah Bernhardt was not photographed the other day as she fell down the flight of stairs at a theatre!"[8] Because of attitudes like this, it is evident why the amateur photographer was held in disrepute and why the public began to retaliate.

A somewhat forthright answer to the amateur was published in 1885. "There is but one remedy for the amateur photographer. Put a brick through his camera whenever you suspect he has taken you unawares. And if there is any doubt, give the benefit of it to the brick, not to the camera. The rights of private property, personal liberty and personal security—birthrights, all of them, of American citizens—are distinctly inconsistent with the unlicensed use of the instantaneous process."[9]

In England "several decent young men" were reported to have formed a Vigilance Association "for the purpose of thrashing the cads with cameras" who take pictures of ladies at the seaside. The writer wished them "stout cudgels and much success."[10]

By the late 1880s the snapshot enthusiast, after displaying an utter lack of integrity or even common good manners, was feared and hated. The problem was exacerbated by the introduction of the first Kodak camera in 1888, which provided a fully self-contained system—the amateur no longer needed to know *anything* about photography. As the Kodak advertisements proclaimed: "You push the button—we do the rest." The Kodak craze swelled the ranks of the amateur snapshooters, and of the social pests, by hundreds of thousands of irresponsible camera

fiends. Violent reactions to the surreptitious use of the camera was not only condoned but applauded, as epitomized by this verse that parodies the Kodak slogan:

> Picturesque landscape,
> Babbling brook,
> Maid in a hammock
> Reading a book;
> Man with a Kodak
> In secret prepared
> To picture the maid,
> As she sits unawares.
> Her two strapping brothers
> Were chancing to pass;
> Saw the man with the Kodak
> And also the lass.
> They rolled up their sleeves
> Threw off hat, coat and vest—
> The man pressed the button
> And they did the rest!

The situation was no laughing matter for the majority of pedestrians. Press reports encouraged the citizen to fight back. In an article titled "The Camera Fiend," *The Chicago Tribune*[11] wrote that "something must be done, and will be done, soon. ... A jury would not convict a man who violently destroyed the camera of an impudent photographer guilty of a constructive assault upon modest women." It recommended that the pedestrian should "fight for his rights" by attacking photographers while hoping that the legislature would pass a law to protect citizens against insult and arrogance from snapshot photographers. The plea for a law against public photography was heard on many occasions after the introduction of the hand camera, but although anti-photography bills were never introduced in Britain and America, a statute prohibiting photography without permission was passed in Germany on July 1, 1907.

Photographic magazines began to give advice on manners and picture-etiquette to their readers, but it was too little, too late. The photographer was more likely to heed the advice of those writers who advocated "that a small revolver may on occasion be a not altogether

undesirable addition to the (photographic) kit; or perhaps some enterprising inventor will 'combine' a shooting instrument with a shutter!"[12] Snapshot enthusiasts were encouraged to "take the precaution to carry a thick stick as part of their equipment, otherwise they may find their cameras reduced to a wreck in consequence of their inability to defend themselves." Another suggestion was the formation of a Photographic Defense Association that would act as bodyguards to amateur photographers while they were shooting in public. This and similar suggestions might seem an over-reaction today, but they were seriously considered in the late nineteenth century, particularly when prominent writers were merely reflecting public sentiment by asserting that because "the hand camera fiend ... respects nothing except the exercise of muscular Christianity upon his carcass, there are cases when damage to person and property would not only be pardonable but meritorious."[13]

Perhaps it is only fair to point out that a high percentage of camera fiends were women. When Prince George of Greece was traveling to America in 1891, he was "pursued by 150 ladies, all armed with cameras, who persisted in photographing him, despite his protests and his attempts to cover his face. This is really a social nuisance, which ought to be sternly repressed."[14] The writer continued, "... but who can effectually guard against the pertinacity of a lady photographer?" *Punch* magazine published many cartoons lampooning the insensitivities of the amateur photographer and of the lady snapshot enthusiast. In one, four women photographers with their cameras are stationed at intervals down a twisting hill, waiting for a male bicyclist to make his descent. The caption runs: "Caution! This hill is dangerous!".[15] In another, an elderly gentleman is hanging from a tree branch over a stream, while three ladies with their snapshot cameras are pursuing their monthly camera club assignment: "A Study of Action."[16] The callousness of these amateur photographers was renowned; both women and men responded to a fellow human being's danger, embarrassment or difficulty merely by seeing the opportunity for a snapshot.

The public indignation over the use of the inconspicuous and surreptitious use of the hand camera prompted for the first time a good many discussions on the morality or ethics of street photography.[17] Issues were raised during this period that have never, and perhaps never will be,

Dust jackets from twentieth century novels that include a photographer as a fictional character. Collection of the author.

resolved due to the infinite varieties of motives from which the pictures are made, as well as to the complexities of personal integrity. As a topic of debate I would offer this 1910 assertion: "Our moral character dwindles as our instruments get smaller."[18]

This was a prophetic statement. With the introduction of smaller, easily concealed cameras with wide-aperture lenses that permitted photographs to be made in situations with low light levels, modern indiscreet photojournalism was born. Newspapers and magazines, with an insatiable appetite for pictures, both reflected and reinforced the photographers' attitude—the picture at any cost. As any impartial observer will admit, no aspect of a life was too private, no tragedy too harrowing, no sorrow too personal, no event too intimate to be witnessed and recorded by the ubiquitous photographer.

Volumes could be written on the moral and ethical choices confronting the photographers of people and events. Suffice it to say that, beginning in the 1880s and continuing through the present, the photographer has been identified with aggression, and this fact is clearly revealed in the fictional characters in twentieth-century literature. For example, a vivid picture of the photographer as aggressor is given in the 1967 novel *The Photographer*, which will serve as a "case history" of the scores of similar themes that reoccur in twentieth-century fiction.

This is an intriguing, well-written study of a photographer's obsession—the taking of a perfect, sensational picture of a violent act, at any cost, including murder. The photographer is willing to sacrifice anything—including honor, the woman he loves, the life of the political leader of his country, even his own freedom for the sake of a single photograph.

The author, Pierre Boulle, is no stranger to violence and aggression. At the outbreak of World War II he was a rubber planter in Malaya, and joined the French forces in Indo-China. When France collapsed, he fled to Singapore and joined the Free French Mission. After the Japanese invasion he was sent via Rangoon and the Burma Road to Kunming, infiltrating as a guerrilla into Indo-China. He was captured in 1942, but escaped after two years and joined the special force in India. Since the war, Boulle has written many books, including *The Bridge Over the River Kwai*, *Planet of the Apes* and *The Executioner*.

Dust jackets from twentieth century novels that include a photographer as a fictional character. Collection of the author.

His novel *The Photographer* is the story of Martial Gauer, who, as a youth in Paris in the early 1930s, had been an active member of an extreme right-wing political group. In Gauer's own words, he was a "professional rabble-rouser," "taking part in every seditious demonstration, dealing out blows with his fist and occasionally with a lead pipe." On the death of his journalist father, young Martial—even his name has aggressive connotations—was forced to find a career, even though he was a half-educated, vicious radical. A photographer friend of his father's, old Tournette, suggested that the young man use a camera. Without much enthusiasm, Martial took the proffered camera to the next political demonstration. As expected, a riot ensued. He began to wield the camera instead of the lead pipe. "He did not press the button until the very moment the weapon landed on the victim's face. This gave him a certain satisfaction, a sense of achievement." One of his political colleagues was surrounded by enemies, but instead of responding to his cries for help, Martial stepped back and photographed the savage beating.

Martial was no longer a participant, but a cold-blooded observer—he was a photographer:

> *He took several exposures, without even hearing the curses the wretched (colleague) yelled at him. Then, as the battle again receded, he shifted his position so as to be closer to the scene of action, not as he used to do, with a show of defiance, but furtively, taking care not to get himself involved and to maintain his freedom of movement, looking all around him with a fresh eye, an eye that was indifferent to the issue at stake in this brawl, unconcerned about distinguishing friend from foe, fired only by the desire to discover some colourful element—an impartial eye, as old Tournette would say.*

For "impartial," read "unfeeling." Martial Gauer had been baptized by violence and was now a full-fledged photographer. He was delighted by the outbreak of war and his excitement, "which had nothing to do with patriotism," was fueled by the possibilities of striking pictures in the violent events. This aggression, lack of feeling and addiction to danger make him a great war photographer, first during the German invasion

of Paris, then in Korea, Indo-China and finally Algeria, where he loses
one of his legs. After that he was reduced to photographing pin-ups in
his studio, now an embittered "artist" still dreaming of the one, last,
sensational picture that would be the culmination of his life's work. The
novel centers around Gauer's obsession with this picture, and how it was
planned. Gauer is privy to an assassination attempt on the president of
France, but instead of foiling the plot, he encourages the plotters and
deviously maneuvers the place and timing of the assassination in order
to provide him with the perfect exclusive picture opportunity, the photo-
graph which would "arouse feelings of frenzy in the general public at
the same time as admiration among connoisseurs and artists—the unmis-
takable hallmark of success."

The dust-jacket of the novel asks: "How far will a frustrated photog-
rapher go to get an exclusive shot ... —" The implicit answer is that the
photographer is capable of *anything,* including murder, in order to
achieve a picture.

If fictional characters are any guide, the public's image of the pho-
tographer is inextricably linked with violence. *Most* of the novels of the
twentieth century that depict photographers relate picture taking to an
act of aggression. From the many available, the following examples will
illustrate the fact.

Two books which deal with presidential assassinations and photog-
raphy, in addition to the one already discussed, are *The Parallax View*
(1970) and *Game Bet* (1981).

*The Parallax View,* by Loren Singer, centers on Tucker, a newspaper
photographer who becomes suspicious about the numbers of his col-
leagues who have died under mysterious circumstances since they witnes-
sed the assassination of the president of the United States during a
motorcade through a major city. He is even more suspicious when it
dawns on him that all his dead colleagues were visible in a two-and-a-half
minute news film of the event, and that the colleagues died in the order
in which they flashed on the screen. Only four photographers and jour-
nalists are left (including Tucker) and clearly have been targeted to be
killed. By whom? Why? Tucker contacts the other three colleagues still
alive. Cooperation is minimal. They are suspicious of each other, and
their efforts at cooperation are marred by jealousy and mutual contempt.

Not one of them is a desirable character. One dies after a homosexual orgy; another is killed while attempting to escape the country. That leaves Tucker, the photographer, and Graham, a journalist. In spite of their vocal and overt distaste for each other, they join forces briefly, follow a few leads and are forced to kill in messy, unprofessional ways. The character differences between the photographer and the journalist are emphasized, and are instructive in this context.

The journalist is "a machine, an intellect, a researcher in behavior or in personality. Not knowing, but deductive, impersonal, unemotional, accurate." It is through this journalist that the reader learns that the assassinations of newsmen have been instigated by an agency of the government. The writer's attitudes to photographers are also clear: "it didn't take much brain to be a photographer," photographers are "venal, self-destructive idiots."

The photographer is a far more disgusting character than the journalist—alcoholic, violent, irrational, sick of society and social mores, and anxious to get even. He began as a pornographer before becoming a newspaper photographer, and does not see much difference between the two. He is just the paranoid, neurotic, aggressive type who is the perfect recruit for the agency he first investigated. His target for assassination is his journalist colleague.

*Game Bet,* by Stockton Woods, is about a photographer who is both aggressor and victim. He boasts of his skill as a rifle marksman and is maneuvered into a bet. To win the bet he must aim a rifle at the President as he rides in a motorcade, but photograph him instead, with a camera mounted on the rifle barrel. For some inexplicable reason he inserts live ammunition in the rifle. Cory, the marksman/photographer, finds a convenient vantage point from which to "shoot" the President, takes his picture, and seems to have won the bet. But then he sees a real assassin aiming a rifle at the President from a neighboring office window. Cory shoots him. Agents and officers hear the shot from Cory's window, assume he is attempting to assassinate the President and fire back. Cory escapes, but although he saved the President's life he is now hunted by every law agency in the country, and all witnesses to the bet end up dead.

It is interesting that even this plot has some historical precedents. Several rifle-cameras were designed in the nineteenth century, and E.J.

Marey devised a photographic gun which he aimed at flying birds like an ordinary rifle. Thomas Skaife constructed a pistol camera and was nearly arrested for attempted assassination after he aimed it at Queen Victoria. Perhaps these, and various other photographers, were subconsciously aware of photography as an aggressive act, and this awareness led to their design of cameras that mimicked guns, rifles and pistols.

It is not unexpected that several variations of the photographer/violence theme occur in *Blind Date* (1977), by Jerzy Kosinski, whose own life has been a mosaic of violent episodes and whose skills include photography. George Levanter, the hero of *Blind Date,* is a Russian determined at any cost to find freedom in the West. He knew that he would need a profession "with a universal language" and became a photographer. Within two years his work is widely published and exhibited, and he receives offers to lecture abroad from several Western art societies. Thinking that his work would be a fine form of advertising for the export of domestic photographic products, the Russian authorities grant Levanter a short-term passport. (This episode closely parallels Kosinski's own efforts to escape from Poland, where he was a prize-winning photographer.) *Blind Date* is episodic in the sense that it is a beautifully constructed patch-work quilt of separate events and characters. Several episodes involve photography, often in connection with violence, such as that in which Levanter witnesses the death of a photographer who was photographing a dignitary when his flashbulb shattered —a common occurrence in the earlier decades. Hearing the loud crack, the security guards drew their guns and fired at the photographer. "Blood poured from his neck and chest, seeping through his clothes, spattering his camera."

Levanter himself commits a particularly brutal murder with cold, calculated deliberation, without regret, and using a photographic metaphor for his act. "But what had taken place there had already receded into a remote corner of his memory. It was nothing but an old Polaroid snapshot; no negative, photographer unknown, camera thrown away."

Susan Sontag's assertion that "to photograph someone is sublimated murder" no longer seems so outrageous.

An important aspect of the photographer-as-aggressor must be the photographer-as-sexual aggressor. Many of the fictional characters in modern literature equate the act of photography with the act of sex. As Sontag says, "To photograph people is to violate them," and to photograph a member of the opposite sex (usually a woman, as most fictional photographers are male) is to rape them. There is no doubt that to many laymen and amateurs the camera is a perfect introduction to a potential sexual encounter. The camera is a tool of seduction. In *Blind Date,* the hero uses a photographic variation of the "come up and see my etchings" routine in order to seduce (unsuccessfully) a beautiful Russian actress.

But the sexual aggression of the photographer was never more clearly expressed than in the movie *Blow Up,* which was based on a short story by Julio Cortazar. The film sequence in which the photographer shoots a writhing model, while constantly driving them both to a visual climax, has become an archetype for the sexually aggressive act of photography. The session begins slowly, the model standing in front of a backdrop and going into standard fashion poses. Music is played— jazzy and sensual. She starts to undulate to the music. The photographer moves in closer. Her movements increase in tempo. They are both on their knees. A new record, and faster music. The photographer is jumping around her, getting more and more excited. "Come on," he says, "that's great. That's great! That's good. Good. Come on, more of that. More of that. Now, give it to me. Really give it to me. Come on, now!" The model lies down on the floor, writhing her body. The photographer stands astride her, bending his legs lower and lower. He's shooting faster. He's getting more and more excited. His movements are wild. "That's great. Good. That's good. That's good. Yes! Go on. That again. That again. That again. Go, go. Great. That's it. Lovely. Love, for me. Love, for me. Now. Now." His voice rises to a crescendo. "Yes. Yes. Yes". He stops—the model slumps back in exhaustion.

It is the classical scene of photography as a sexual act. Its potency is attested to by the fact that if there were not many photographers behaving in this manner prior to the movie, there were thousands imitating the photographer in subsequent years. This sensual frenzy in a studio has become a cliche, perhaps, but a cliche is only a truth too often repeated. The movie *Blow Up* represents a watershed in the twentieth-

century attitudes to the photographer; it both reflected and led a social and cultural movement in the medium.

A recent novel infinitely more intelligent and challenging than any of the books already mentioned is *The Sightseer* (1973), by Geoffrey Wolff. The whole book is a sustained comic/tragic metaphor in which the author is a lens, and life a big movie in the making. As one reviewer succinctly noted: "The ruthless lens moves about like a weapon, a penis: no wonder primitive people see 'taking' a picture as a kind of rape."[19] This is one of the most serious and profoundly introspective books to attempt to depict the character of a photographer. There is a lot of philosophizing about visual meaning and a good deal of traumatic self-examination of the photographer's motives, one aspect of which was the photographer as aggressor. "Armed with a lens to inject between myself and the world, I thought of myself as a formidable, deadly fellow. After all, I arranged the world to fit the dimensions of my viewfinder. At large among people, carrying my Leica or my movie camera, cool-eyed, deliberate, editing from the earth's face whatever was useless or gross, I could take the trophies I wanted. Find, fire, freeze. I was a predator." The photographer takes no responsibility for reality, only for the final image.

The theme of the taking of a photograph as a violent act, often with sexual connotations, is incessant and insistent throughout the literature of this century—but it should be emphasized that some critics and social historians have insisted that there is a close relationship between all arts and violence, particularly in recent decades. The photographer-as-aggressor should also be seen in this wider cultural context. Arnold Hauser, in *The Philosophy of Art History,* insists that:

> *The spiritual world of the artist may be incomparably more com-*
> *plex than that of the criminal, but as far as the relation between*
> *individual freedom and social causation goes, there seems to be no*
> *difference in principle between the creation of a work of art and*
> *the commission of a crime.*[20]

The question remains: Is there something *especially* aggressive about the act of photography?

NOTES

1  Susan Sontag, *On Photography,* Farrar, Strauss, & Giroux, New York.
2. Sontag's four esays were originally published in *The New York Review of Books,* between October 1973 and November 1974.
3. *The British Journal of Photography,* September 10, 1881.
4. The *New York Times,* August 1884.
5. February 23, 1884.
6. For example, see the *New York Times,* April 21, 1883 and March 23, 1884.
7. For example, see "Photography and Blackmail", the *New York Times,* April 21, 1883.
8. *The Amateur Photographer,* September 18, 1885, p. 871.
9. *The Amateur Photographer,* September 27, 1885, p. 397. Reprinted from an unnamed American periodical.
10. *The Amateur Photographer,* September 27, 1895, p. 194. Reprinted from the *Weekly Times and Echo.*
11. See: "What is to be done about the camera fiend", *American Amateur Photographer,* vol. XVIII, 1906, p. 103.
12. *Birmingham Daily Mail,* August 2, 1980.
13. *The Photographic News,* May 1, 1896.
14. *The Photographic News,* July 31, 1801, p. 544.
15. *Punch,* June 7, 1899, p. 273.
16. *Punch,* September 5, 1906, p. 171.
17. A good example is "The Ethics and Etiquette of Photography", *The Independent,* vol. LXIII, July 11, 1907.
18. *The Amateur Photographer,* October 4, 1910, p. 340.
19. Norman Shrapnel, *The Guardian,* September 7, 1974.
20. Arnold Hauser, *The Philosophy of Art History,* 1969, p. 276.

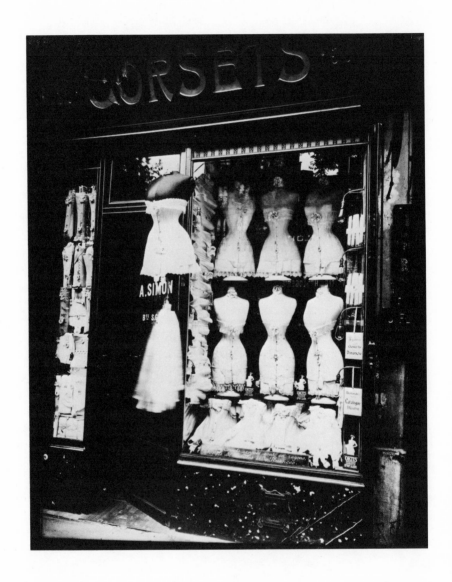

Photograph by Eugène Atget. *Boulevard de Strasbourg, Corsets, 1912.* Courtesy the Museum of Modern Art, New York.

# ATGET, PRECURSOR
# OF MODERN DOCUMENTARY PHOTOGRAPHY

## Maria Morris Hambourg

Eugène Atget died in Paris on August 4, 1927, precisely when needed by modern movements in photography. Once the intransigent old man was gone, young photographers of several persuasions could hail his vision as an antecedent to their own and find the comfort of a tradition in his example. Dead, but not so long he was forgotten, Atget was the only nineteenth-century photographer whose works figured in all the early landmark exhibits establishing modern photography as a sovereign art: The first Independent Salon of Photography in France (1928), the first group exhibit of modern photography in Belgium (1928), the all-important traveling exhibition of the new photography in Germany (1929) and the first independent exhibition of modern photography in America (1930). In just three years he had become associated with the most recent tendencies and had been introduced to America as the precursor of modern documentary photography.

In the years following Atget's death his work was championed by three sorts of partisans: those who claimed photography as a surreal art, those who supported it as a fine art and those who admired it as a technological art. The Surrealists considered the camera a servant of the imagination and reveled in its automatism, its banal recordmaking capacity and its potential for fantastic plastic invention. They found certain of Atget's pictures interesting because they fixed and isolated ordinary objects, freeing them of conventional associations to divulge their animistic singularity. Promoters of the fine arts argued that photography was not a mechanical transcription of reality or a poor cousin to

painting, but a valid vehicle of subjective expression. These men appreciated the photographer's unswerving allegiance to his unique art. Advocates of technology saw photography as a wondrous tool for discovering new forms and for extending human vision beyond its frontiers. Their respect for sharply focused pictures of the world and their distaste for painterly pastiche cast Atget in a positive light as historic harbinger of the new camera vision.

The Surrealists were the first to appropriate Atget to their cause. It is well known that Man Ray "discovered" Atget, his neighbor on the rue Campagne-Première, two or three years before the old man's death, and published four of Atget's photographs against his wishes in *La Révolution surréaliste* in 1926.[1] Man Ray shared his enthusiasm for Atget's work with his many associates, among them Tristan Tzara, Jean Cocteau, Julien Levy and Berenice Abbott, Man Ray's assistant. Through her efforts, the circle of Atget's admirers widened to include the Surrealist poet Robert Desnos, his friend Pierre Mac Orlan and Albert Valentin. These men saw Atget as a primitive of his art, a sort of Douanier Rousseau of photography who independently discovered the means of capturing the bizarre inherent in the ordinary. They compared his vision with the poetry of Arthur Rimbaud, Gérard de Nerval and Louis Aragon, and with the popular mystery films "Fantômas," which they loved for their naivete, their sinister mood and their realistically detailed decor.

Although Man Ray was responsible for initiating Atget's association with Surrealism, his attitude toward Atget was ultimately disparaging. The writers who seconded his initial motion—Desnos, Mac Orlan, and Valentin—were more magnanimous, however. Unafflicted by the myopia of Man Ray's stylized photographic art, these writers imagined for Atget visionary powers similar to their own. Desnos proposed that Atget's so-called documents were really "visions of a poet, bequeathed to poets." Knowing no precedent for this transcendent use of the camera, Desnos presumed Atget to be the unconscious originator of a new art. "His mind was of the same race as the Douanier Rousseau's and his vision of the world, while fixed through an apparently mechanical medium, was also the vision of his soul."[2] Valentin likewise praised Atget for providing our "access to an extraordinary mental landscape which balances, fascinatingly, between fact and dream. The paradox of Eugène Atget is not just

that this primitive was such a visionary, endowed with such prescience, but that the instrument he chose to express his vision had no past, and no guarantee of its efficacy."[3]

While Valentin and Desnos dwelled only in poetic realms, Pierre Mac Orlan cast the Surrealist idea of Atget over the visual attributes of the photographic image. Mac Orlan hailed Atget as a seer of the invisibly charged penumbra of the phenomenal world, a photographer of the subliminal landscapes of the contemporary age. Although he had adopted the notion of an urban space animated by the modern psyche from Surrealist literature (e.g. Aragon's *Paysan de Paris* and Andre Breton's *Nadja*), Mac Orlan was not a Surrealist. He was a novelist known for his haunting, atmospheric settings (e.g. *Ouai des Brumes,* 1927). This master of the mysterious "mise-en-scene" admired photography's ability to freeze the unconscious moment and isolate sections of the larger context, and thus recognized in Atget's life work a visual anthology of the myriad facets of the kaleidoscope of modern life.[4]

The second group of Atget enthusiasts, less radical than the Surrealist coterie but influenced by it, was composed of men who absorbed avant-garde ideas and popularized them. Its members, writers and editors of fashionable arts magazines in Paris, functioned, albeit in no organized fashion, as a body supporting photography's recognition as a fine art. Principal figures were Florent Fels, editor of *L'Art vivant;* his cohort Georges Charensol; Louis Cherronnet, editor of *Art et décoration;* Jean Galtier-Boissière, editor of *Le Crapouillot;* Christian Zervos, editor of *Cahiers d'art;* Waldemar George, contributor to *Arts et metiers graphiques;* and Pierre Bost and Carlo Rim, roving writers, illustrators and promoters of the arts. If these men shared a creed, it was simply to uphold contemporary trends in the arts. Thus they embraced the cinema and praised the new films by René Clair, Alberto Cavalcanti, Georges Lacombe and Man Ray, and naturally rallied to the aid of modern photography, too.

Florent Fels was most important in this regard. In 1925 he published a pioneer article on new French photography, "Le Miroir aux Objets," in which poet Réné Crevel discussed photography's non-objective character as its artistic prerogative.[5] The following year, Fels wrote to Atget requesting some photographs "of shops, artistic landscapes, the zone,

etc."[6] Atget apparently complied, for his pictures began to turn up in the pages of *L'Art vivant* thereafter. In October 1927, Fels ran a review of the Salon de la Photographie, an annual exposition of rear-garde pictorialism held by the Société française de la Photographie and the Photo-Club de Paris.[7] Deploring this generally sentimental art, *La'Art vivant* called for an antidote in the form of a "salon des independants." In the subsequent number, Georges Charensol reiterated the call, now specifically suggesting exhibitions of "our best photographers, the Man Rays, the Abbes, the Berenice Abbotts."[8] From this seed grew the *Premier Salon Indépendant de la Photographie*, held in the stairway galleries of the Theatre des Champs-Elysees in May and June of 1928.

The *Salon de l'Escalier*, as it was called, was hastily organized by Florent Fels and Georges Charensol with the aid of Jean Prévost and Lucien Vogel.[9] It featured the work of Nadar (père et fils), and Atget, Berenice Abbott, Andre Kertész, Germaine Krull and Man Ray, society portraitists d'Ora and Albin-Guillot, *Vogue* photographers George Hoyningen-Huene and Paul Outerbridge. The catalogue stated that the purpose of the exhibit was to prove that photography was not a mechanical derivative of reality or a slave of painterly styles, but an independent artistic medium with its own aesthetic.

The show was a critical success for the modern movement in French photography and clinched Atget's place within it. Pierre Bost quibbled with the stated aims, but praised the works he saw.[10] Waldemar George considered the goals already won, and compared Atget's talents to those of Claude Monet, Giorgio de Chirico, Max Ernst and Louis Aragon.[11] The reviewer for the *Chicago Tribune* commented on the works of the Americans Abbott and Man Ray, and on those of Atget, "who died a year ago. ... His study of an old, worn-out stairway is perhaps the best composition in this corner of the salon. Although comparatively a pioneer in the art, many of his compositions rank with the best of the modern works."[12] Fels and Charensol naturally gave the show good coverage in *L'Art vivant*, expanding on the stated premise, on the genius of Nadar and Atget and on the characteristics of the new generation. Because of Fels' part in the undertaking, his remarks are of particular interest.

> *The arbitrary grouping of these few names indicates the goals pursued by the exposition's organizers. It was less a question of showing the public a panorama of contemporary photography than of drawing its attention to the work of precursors and accomplished practitioners, all of whom manifest a certain point of view. We wanted to avoid above all "artistic photography," that photography which takes its inspiration from painting, engraving and drawing. Certain English artists have a mania for treating their subject in chiaroscuro, attempting to give their works a Rembrandt effect, or the look of a Carriere. Some Frenchmen manage to make their models look like a Helleu or a Brisgand; others take up photography to achieve an Impressionist technique, which gives us sunsets along the Seine and light in the branches of the underbrush —a whole aesthetic of painterly goals that escapes the rigorous principles of photography consecrated to two tones, black and white. ... Due to the exigencies of the exhibition space, the organizers had to neglect some excellent photographers. But two names immediately imposed themselves: Nadar and Atget.*

After explaining who Nadar and Atget had been and discussing the contributions of the younger generation, Fels concluded:

> *All take care to be exact, clean, precise. They avoid the "flou" that only the cinema rightfully ought to use. They do not cheat either the model or the metier, which, to qualify as an art, must possess its own laws. A good photograph is, above all, a good document.*[13]

On the heels of this introduction, modern documentary photography was seen with much greater frequency in France, and then in Belgium, in both publications and exhibitions.[14] The incentive of the *Salon de l'Escalier* also encouraged the Galerie de l'Epoque to arrange an exhibit of the new photography in Brussels in October 1928.[15]

Another immediate result of the salon was Berenice Abbott's long-awaited meeting with André Calmettes, an old friend of Atget's from his acting days, and executor of his estate. When Calmettes learned that

Abbott had loaned photographs she had bought from Atget to the *Salon de l'Escalier,* he invited her to come to discuss "the matter that interests you."[16] The successful outcome of their encounter was announced in the *Chicago Tribune* June 27, 1928: "American buys famous collection of Atget, Paris photographer."

The sale of the collection made Atget's work widely available, for Abbott made it her business to show the photographs to friends and associates, to loan prints for publication and exhibition and to assure that Atget's work was given the same exposure as her own everywhere. Her enthusiastic proselytising and the spotlight Atget's photographs received at the Galerie de l'Epoque in the fall incited great interest. Before the end of 1928 *Variétés* had featured Valentin's important essay on Atget with a portfolio of his photographs. The eight pictures represented street scenes, *fêtes forains,* boutiques (and mannequins), and the *petits metiers,* a selection quite typical of the taste of the period. (Photographs of architecture and of the small towns and formal gardens in the environs of Paris were rarely published. Carlo Rim also illustrated the initial number of his new magazine *Jazz* with five of Atget's prints, and Christian Zervos broadcast the news of the Brussels show and of Atget's signal importance in *Cahiers d'art:*

> *The first to have given capital importance to documentary photography was E. Atget, who died last year in Paris. Who among us does not remember this old man who knocked at every door in Montmartre to show and sell artists prints of his Parisian views which captured all the metiers, quarters and types of the past half-century? For those who are unacquainted with Atget, Mlle. Berenice Abbott is preparing with great devotion a very important work collecting the best of Atget's pictures with a commentary by Paul Claudel (sic). The appearance of this work is indispensible for it will instruct us in a preemptive fashion of the unsuspected significance of documentary photography, which already counts among its adherents such well-known names as the Hungarian Andre Kertész, the American Sheeler, the Belgian E. Gobert, Germaine Krull and Eli Lotar.*

Zervos then mentioned Abbott's portraits and the "plastic" photographs of Man Ray and Moholy-Nagy also on view at the Galerie de l'Epoque, and in conclusion announced that both the documentary and the plastic tendencies would be surveyed in the universal exposition of film and photography to open the upcoming spring in Stuttgart.[17]

The beginning of an awareness in 1928 of more than one tendency in modern photography, the appearance and discussion of photographs in modish French arts magazines (not just Surrealist organs) and the initial contacts of contemporary photographers of different nationalities presaged the events of the next two years. The pluralistic international point of view reached full extension not in France or in Belgium, however, but in Germany. While France was accustomed to welcoming foreign artists as participants in French creative movements, Germany sought ramifications of artistic trends beyond its own borders. It was thanks to effective German organization and propaganda that the new vision in photography gained international status, and that Atget's privileged position in French photography was transferred to the modern movement as a whole.

German attitudes toward artistic photography progressed in tandem with developments in the photographic industry. Respect for the pictorialist art of the pre-war period eroded as photography assumed new commercial and industrial uses in the 1920s. Trade fairs encouraged technical advancements, and the German Werkbund and the Bauhaus explored commercial, expressive and formal applications for the new technology. The eighth Bauhaus Book, Moholy-Nagy's *Malerei, Fotographie, Film* (1925) and Albert Renger-Patzsch's *Die Welt ist Schön* (1928), established the poles of a critical dialogue. According to Moholy, photography was the appropriate idiom of visual culture; it had the independent existence, strengths, ambiguities, formal potential and conventions of all language. For Renger-Patzsch, the camera was the tool to lay bare the objective structure of reality. A general acceptance of all purely photographic images, whether produced by art or industry, bridged these positions.

Atget's unadulterated, sharp-focus documents were welcomed into this theoretical arena, first at an exhibition at the Folkwang Museum in Essen in January 1929. The exhibit, *Fotografie der Gegenwart* (Contem-

porary Photography), was divided into five sections: The Beautiful Picture, The Image in the Service of Science and Research, Free Photographic Form (photograms), Photomontage and Film Stills. In the first category, contributors were primarily German and French, among them Herbert Bayer, Karl Blossfeldt, Moholy-Nagy and Otto Umbehr (Umbo), Atget, Abbott, Florence Henri, Kertész, Krull, Lotar and Man Ray.[18] *Fotografie der Gegenwart* was not the first exhibit to juxtapose creative photography with photography of science and industry, for that was the inheritance of the trade fairs, but it was the first to attempt a large French representation, and the first to include Atget.

More cogently edited and better publicized was the German Werkbund's large exhibit *Film und Foto,* which opened in Stuttgart in May 1929 and was subsequently seen in Berlin, Munich, Vienna, Zagreb, Basel and Zurich. Truly international in scope, the show contained works by American, Belgian, Dutch, Swiss and Russian artists in addition to German and French. Selection was by committee, aided by consultants in each country. The French consultant was Christian Zervos,[19] who had recently learned from Abbott of Atget's unparalleled significance for documentary photography. The latter's prominence in *Film und Foto* (where eleven of his pictures were hung) is thus traceable to Zervos and through him to Berenice Abbott, conduit of so much of the attention paid to Atget.

Two trend-setting books accompanied the exhibit and added greatly to its impact and longevity, especially in America—Werner Graeff's *Es Kommt die neue Fotograf!* and Franz Roh and Jan Tschichold's trilingual *Foto-auge.* In them, as in the exhibition, the emphasis was on modes of representation thought to be purely photographic. Of these, description or documentation of the objective world was proposed as the most basic.

The historic legitimacy of this "normal" camera vision was established by Franz Roh in *Foto-auge:*

> *The history of photography hitherto shows two culminating modes. The first at the beginning of development (Daguerre), the second at the end. ... The greatest part of what has been produced between this beginning and end is questionable, because a frank or disguised attempt was made to imitate the charm that belongs*

*either to painting or to graphic art. This of course was a deviation*
*from the proper task of photography.*[20]

Atget's photograph of a corset shop on the Boulevard de Strasbourg
was the first in the book. The message implied was clear—if acceptable
modern photography begins with the recovery of typically photographic
modes of rendering, then the late Eugène Atget was the first modernist.
In the synoptic view of history at *Film und Foto,* he was the pioneer who
rejected pictorialism and brought photography's proper heritage into
focus and up to date.

Atget's work was repeatedly brought to the fore during 1929 and
1930. As Janet Flanner put it in the *New Yorker,* "After seventy years
of obscure living and dying, Eugène Atget, the most remarkable photo-
graphic documentor of his day, is now featured in all the avant-garde
European reviews."[21] In 1929, articles about Atget and dozens of repro-
ductions of his work, appeared in *L'Art vivant, transition, le Crapouillot,
Jazz, Creative Art* and the Dutch periodical *Elsevier's Monthly.*[22] This
acclaim for Atget's work continued through 1930, but at a somewhat
reduced level,[23] for in the middle of 1929 Berenice Abbott had taken her
collection and her considerable energies back to New York on the
*Mauretania.* The most significant contribution to Atget's growing fame
was with the publication of French, German and American editions of
a book of nearly a hundred reproductions of Atget's photographs. *Atget,
Photographe de Paris,* prepared by Berenice Abbott and Henri Jonquières
in Paris, was the first monograph on any photographer to be published
on both sides of the Atlantic and in two languages.[24]

In New York, the Wehye Gallery sponsored the American edition
of the book and mounted the first one-man show of Atget's photographs
in the United States (November 24 to December 6, 1930). A small leaflet
announcing the event stated, "Eugène Atget died in 1927 in Paris, an old
man, precursor to the vision of an epoch."[25] After describing the pho-
tographer's subjects, the anonymous author cribbed from Desnos, "his
viewpoint of the world, determined by an apparently mechanical
medium, was also the vision of his soul." He concluded with a quotation
from Mac Orlan: "The art of photography is the expression of our
epoch. For this reason it is not as yet understood by most people, who

are not able to understand the age itself. Was Atget at the source of this new expression?" This concise, provocative dispatch, along with Mac Orlan's longer essay (in French in the Weyhe edition) introduced Atget's work to New York.

At the same time (November 1930), the Harvard Society for Contemporary Art included Atget's pictures in an exhibition of modern photography that was without precedent here.[26] A catalogue, most likely the work of Lincoln Kirstein, stated that the exhibition intended "to prove that the mechanism of the photograph is worthy and capable of producing creative work." Adopting Franz Roh's view of history from the "admirably edited" *Foto-auge*, the writer launched the now familiar argument that there had been two great periods in photography, and between Daguerre and Stieglitz a period of painterly decadence. "The war hit a final blow to impressionism in photography. The necessity for simple clarity in documentary form opened the eye of the camera to the approach for which it was originally intended." Then, in rather odd syntax, he elaborated, "Through a documentary medium as in Atget, it can be used far more than as a means of documentation; as a plastic it is capable of strength and analytical nuance as a sculpture (Steiglitz); in dramatics it is as monumental as architectural development (Eisenstein)." The exhibit contained ten of Atget's prints on loan from the Weyhe gallery, ten portraits by Abbott (including one of Atget), and works by Margaret Bourke-White, Anton Bruehl, Walker Evans, Arthur Gerlach, Pirie MacDonald, Tina Modotti, William Rittase, Charles Sheeler, Sherril Schell, Edward Steichen, Ralph Steiner, Alfred Steiglitz, Paul Strand, Doris Ulmann and Edward Weston, as well as aerial, astronomical, press and x-ray photographs. Without the pretensions that would accompany such a claim, the exhibit put together by Kirstein and his associates was a miniature, virtually all-American version of *Film und Foto*. Here, too, Atget figured as the only precursor, and now a specifically *documentary* exemplar.

American reception of Atget's work almost totally lacked the mysticism characteristic of the Surrealist response in Europe. Atget was received here as an artist whose work escaped the artifice typical of his epoch because his purpose was "simply" documentary. Paul Rosenfeld, reviewing the new monograph for *The New Republic*, went so far as

to attribute the success of the work to "Paris, the Artist." "For Atget, certainly, the matter alone was generative," Rosenfeld stated, "the camera a pure instrument of record."[27] A less extreme view, and the one which has come to be classic, was that of Walker Evans, who was forging his art on Atget's model. Friend of Berenice Abbott and protege of Lincoln Kirstein, Evans chose (or was chosen) to review the Atget book and five other important new books for Kirstein's magazine *Hound and Horn*.[28] In his acutely insightful piece, "The Reappearance of Photography," he established Atget's place in history and plotted the program for modern documentary photography.

Following Kirstein's precedent of the Society catalogue, Evans took up Roh's argument:

> *The real significance of photography was submerged soon after its discovery. ... The latter half of the nineteenth century offers that fantastic figure, the art photographer, really an unsuccessful painter with bag of mysterious tricks. ... Suddenly there is a difference between a quaint evocation of the past and an open window looking straight down a stack of decades. ... Actual experiments in time, actual experiments in space exactly suit a post-war state of mind. The camera doing both, it is not surprising that photography has come to a valid flowering—the third period of its history.*

Having thus set the historical stage, Evans introduced the protagonist:

> *Certain men of the past century have been renoticed who stood away from this confusion. Eugène Atget worked right through a period of utter decadence in photography. He was simply isolated, and his story is a little difficult to understand. Apparently he was oblivious to everything but the necessity of photographing Paris and its environs; but just what vision he carried in him of the monument he was leaving is not clear. It is possible to read into his photographs so many things he may never have formulated to himself. In some of his work he even places himself in a position to be pounced upon by the most orthodox of surrealists. His general note is lyrical understanding of the street, trained observation of it,*

*special feeling for patina, eye for revealing detail, over all of which
is thrown a poetry which is not "the poetry of the street" or "the
poetry of Paris," but the projection of Atget's person.*

In one motion, Evans handily discounted the Surrealist interpretation of
Atget's work and corrected Rosenfeld's misattribution of the source of
the poetry in Atget's pictures. Through a judicious choice of phrase, the
intangible autographic quality we usually call style was removed from
the realm of vague spirituality, what Desnos had called "the vision of
his soul," to the unimpeachably circumspect locution, "the projection of
Atget's person."

Continuing his discussion, Evans dealt with each of the other five
books. He dismissed Steichen's "technical impressiveness and spiritual
non-existence,"[29] criticized Renger-Patzsch's method as "a roundabout
return to the middle period of photography," assessed *Foto-auge* as "a
nervous and important book," and put Waldemar George's *Photographie
vision du monde* in its place, "valuable in its French-intellectual way."
He concluded with August Sander's *Anlitz der Zeit:*

> *Finally the photo document is directed into a volume, again in
> Germany. Anlitz der Zeit is more than a book of "type studies;"
> a case of the camera looking in the right direction among people.
> This is one of the futures of photography foretold by Atget. It is
> a photographic editing of society, a clinical process; even enough
> of a cultural necessity to make one wonder why other so-called
> advanced countries of the world have not also been examined
> and recorded.*

Like a navigator progressively fixing his vessel's position, Evans
defined modern documentary photography as a cultural necessity
foretold by Atget, a photographic editing of society effected by a camera
looking in the right direction. Ostensibly mechanical and intentionally
clinical, documentary photography nonetheless might transcribe a certain
poetry, the projection not of the thing seen but of its seer.

Evans' understanding of the photographer's moral purpose and his
high regard for Atget were shared by other documentary photographers

in the thirties. What made Atget so compelling to them was not just the beauty and the seemingly straightforward style of the individual pictures, but also the principled stance toward the world which the work as a whole revealed. For a generation seeking an alternative to both fin-de-siècle pictorialism and the formal experimentation of the twenties, Atget's example established a precept for treating significant subject matter with uncontrived honesty. "There is no superimposed symbolic motive, no tortured application of design, no intellectual axe to grind," wrote Ansel Adams in 1931.[30] "I feel," he continued prophetically, "that photography will find itself in the not too distant future reverting to the simplicity of style that distinguished the historic work of Atget."[31]

## NOTES

1. June and December issues. See Paul Hill and Tom Cooper, "Interview: Man Ray" *Camera*, 54, no. 2 (Feb. 1975), pp. 37-40; and the author's "A Biography of Eugène Atget" in John Szarkowski and Maria Morris Hambourg, *The Work of Atget, The Art of Old Paris* (New York: The Museum of Modern Art, 1982), pp. 9-10, and note 3.

2. Albert Valentin, "Eugène Atget (1856-1927)" *Variétés*, 8 (Dec. 15, 1928), pp. 403-407.

3. Robert Desnos, "Les Spectacles de la rue: Eugène Atget" *Le Soir*, (Sept. 11, 1928).

4. Pierre Mac Orlan, "L'Art litteraire de l'imagination et la photographie" *Nouvelles littéraires* (June 22, 1928); "La Photographie et Le Fantastique Social" *Les Annales*, no. 2321 (November 1, 1928), pp. 413-414; and "Photographie; Elements de Fantastique Social" *Le Crapouillot* (January 1929), pp. 3-5.

5. *L'Art vivant*, 1, no. 14 (July 15, 1925), pp. 23-24.

6. Letter dated May 8, 1926 from Florent Fels to Monsieur Atget (Atget Archives, The Museum of Modern Art, New York).

7. Luc Benoist, "L'Art de la Photographie" *L'Art vivant*, 3 (Oct. 15, 1927), pp. 844-45, 856.

8. Georges Charensol, "Les Expositions" *L'Art vivant*, 3 (Nov. 1, 1927) p. 900. The Abbe referred to was James Abbe, American photographer (1883-1973), then working in Europe for *Harper's Bazaar, Vu* and *Vogue*.

9. [Catalogue] *XIX<sup>e</sup> Salon de l'Escalier* (Paris: Comédie Champs-Elysées, 1928). Abbott Scrapbook (Atget Archives, MOMA. Although the catalogue lists René Clair among the organizers, the late filmmaker denied having any part in the exhibit. Letter to the author of July 13, 1979 (Atget Archives, MOMA).

10. Pierre Bost, *La Revue hebdomadaire*, 24, (June 16, 1928), pp. 356-59,

11. Waldemar George, "Le Salon de la Photographie au Salon de l'Escalier" *Presse et Patrie* (June 11, 1928), Abbott Scrapbook (Atget Archives, MOMA).

12. "Oldest and Newest in Photographs Contrasted in Unique Exhibit" *The Chicago Tribune*, (May 26, 1928). Abbott Scrapbook (Atget Archives, MOMA).

13. Florent Fels, "Le Premier Salon Independant de la Photographie" *L'Art vivant*, 4 (June 1, 1928), pp. 444-45.

14. Portraits by Abbott and Man Ray, unofficial photographers for Shakespeare and Company, began to appear regularly in Eugene Jolas' magazine *transition*; Man Ray's photographs of heavy industry were commissioned by and published in *Vu*; Krull's photographs were published in a monograph with introduction by Fels (*Métal*, 1929), and photographs by Abbott, Man Ray and occasionally Kertész, appeared in the French-Belgian review, *Varits*.

15. [Catalogue] *Une Exposition de photographie à la Galerie l'Epoque* (October, 1928). Abbott Scrapbook (Atget Archives, MOMA). The first picture in the show was Abbott's portrait of Atget, followed by sixteen of his original prints, and approximately a dozen photographs each by Abbott, Kertész, Krull, Eli Lotar, Man Ray, Belgians Robert Desmet, E. Gobert and E.L.T. Mesens, Aenne Biermann, Lazlo Moholy-Nagy and Robertson. The catalogue essay was by Pierre Mac Orlan—a reprint of his recent article in *Nouvelles littéraires*.

16. Letter of June 11, 1928, from Andre Calmettes to Berenice Abbott. (Atget Archives, MOMA).

17. "Bruxelles, Exposition de photographie" *Cahiers d'Art*, 3, no. 8 (1928), p. 356.

18. [Catalogue] *Fotografie der Gegenwart* (Essen: Folkwang Museum, January-February 1929). Abbott Scrapbook (Atget Archives, MOMA). After the Essen showing the exhibition traveled to Hanover.

19. Ute Eskilden, "Innovative Photography in Germany Between the Wars" *Avant-garde Photography in Germany 1919-1939*. (San Francisco: San Francisco Museum of Modern Art, 1980), p. 39.

20. Franz Roh, "Mechanism and Expression: the Essence and Value of Photography" Introduction to *Foto-auge*, 1929. Reprint (New York: Arno Press, 1973), p. 14.

21. *The New Yorker* (May 4, 1929), reprinted in Janet Flanner, *Paris was Yesterday* (New York, Popular Library, 1972), p. 50.

22. Jean Galliotti, "La Photographie est-elle un art? Atget" *L'Art vivant*, 5 (January 1, 1949), p. 24, with cover and 7 reproductions under title "Un Précurseur de la photographie moderne: Adjet (sic);" B. J. Kospoth, "Eugène Atget" *transition*, 15 (February 1929), pp. 122-124, with 2 reproductions; *Le Crapouillet* (May 1929), special number with cover and 30 reproductions; *Jazz*, 7 (Summer 1929) 1 reproduction; Robert Desnos, "Emile Atget (sic)" *Merle*, n.s., no. 3 (May 3, 1929) reprinted in Robert Desnos, *Nouvelles Herbrides et autres textes 1922-1930* (Paris: Gallimard, 1978); Berenice Abbott, "Eugène Atget" *Creative Art* 5, no. 3 (September 1929), pp. 651-656 with 7 reproductions; Maud Kok, "Atget, 1856-1927" *Elsevier's Monthly* (August 1929), pp. 94-97 with 2 reproductions.

23. Waldemar George gave Atget an important place in his historical anthology, *Photographie vision du monde*, a special number of *Arts et metiers graphiques* (March 15, 1930), pp. 134-138 with 2 reproductions; and Carlo Rim included Atget alongside Kertész, Roger Parry and Maurice Tabard in his exhibition of modern photography at the *Onzième Salon de l'Araignée* (Paris, 1930).

24. *Atget, Photographe de Paris* (Paris: Henri Jonqieres, 1930); (New York: E. Weyhe, 1930). *Atget: Lichtbilder* (Leipzig: Verlag Henri Jonquieres, 1930).

25. From the example in the collection of Carleton Willers, New York.

26. The society was directed by three students, Lincoln Kirstein, John Walker and Edward Warburg under the tutelage of Professor Paul J. Sachs. The five-page catalogue *Photographs* (November 7-29, 1930) with its unsigned "Introductory Note" is to be found in Kirstein's scrapbooks concerning the society in the Special Collections Library, The Museum of Modern Art, New York. I am endebted to Sandra S. Phillips for directing my attention to this exhibition and for sharing much additional information on the period.

27. Paul Rosenfeld, "Parish, the Artist" *The New Republic,* 65, no. 843 (Jan. 28, 1931), pp. 299-300.

28. Walker Evans, "The Reappearance of Photography" *Hound and Horn,* 5, no. 1 (Oct.-Dec., 1931), pp. 125-128.

29. The book under review was Carl Sandburg's *Steichen the Photographer* (New York: Harcourt, Brace, 1929).

30. Ansel Adams, "Photography" *The Fortnightly,* 1, no. 5 (Nov. 6, 1931), p. 25.

31. Ansel Adams, "Photography" *The Fortnightly,* 1, no. 8 (Dec. 18, 1931), p. 22.

Photograph by Dorothea Lange. *Filipinos Cutting Lettuce, Salinas Valley, California, 1935.*
Courtesy the Lange Collection, The Oakland Museum.

# PHOTOGRAPHIC FACTS AND THIRTIES AMERICA

*Anne Wilkes Tucker*

A merican documentary photography as it evolved in the 1930s had ardent advocates and detractors. There was little agreement about the practice, purposes and values of photographic documentation, but all sides acknowledged that the distinguishing feature of documentary photography was its use of natural materials and "straight" technique. Photographic documents isolated and defined actuality; they possessed a quality of authenticity that led to their use as evidence. But while facts were acknowledged as the basic component of documentation, the information conveyed by photographic facts could be sharply altered, even totally transformed, by the sequence and manner of its presentation.

The careers of Margaret Bourke-White, Walker Evans, Dorothea Lange and Paul Strand provide cogent examples of the diverse interpretations of what constituted documentary photography. These photographers embody in their work the central artistic and social issues of the thirties, and each of them significantly influenced the documentary genre.

The term *documentary* was first used in 1926 by the English filmmaker John Grierson to describe Robert Flaherty's film *Moana*. For the next thrity years, Grierson was a formative critic of the international documentary film movement; in his writings and in his own documentary films, Grierson declared a larger purpose than a simple recording of reality. He believed that documentaries should educate and persuade. He worked for "selective dramatization of facts in terms of their human consequences."[1] For Grierson, documentaries were the means of educat-

ing "our generation in the nature of the modern world and its implications in citizenship."[2]

Grierson's arguments were rephrased and placed in context in an article "The Film Faces Facts," by Richard Griffith.[3] While he spoke only of documentary films, his observations applied as well to documentary photography, and a summary of the issues as Griffith saw them is very useful in understanding the evolution of the term *documentary* in the thirties. He began by recognizing that "the word [documentary] has been generally used to describe any film which deals with real life from any point of view whatsoever."[4] He continued,

> *If facts are to be conveyed understandably and palatably to a lay audience, they must be expressed in terms of their human consequences. And interpretation of social facts to lay audiences is the most important educational function the documentary film can perform. It is primarily not a fact-finding instrument, but a means of communicating conclusions about facts.*[5]

This opinion aligned Griffith's ideas with those of Grierson and others who believed that social facts were more important subjects for the documentary than environmental, psychological or historical facts. By measuring the fact "in terms of its human consequences," they meant that the individual should be shown undergoing the social forces that shaped his life. These artists intended not only to reveal operative social forces, but also to suggest ways to deal with them. They were, quite frankly and forthrightly, propagandists.

Not all documentary artists were propagandists, and the actions urged by those who were ranged widely from civic participation to revolution. Inclusion of *any* propaganda brought attack from political conservatives and aesthetes. Moderate liberals like Grierson sharply criticized productions of the radical left; the radicals reciprocated in kind. Artists with radical or moderate political goals criticized any documentary image whose beauty detracted from its message.

Paul Rotha, a colleague of Grierson's, put the conflict between art and photographic evidence lucidly. "Beauty is one of the greatest dangers of documentation."[6] Griffith elaborated further:

> *Social facts are dramatic in themselves, but their dramatic quality must be expressed in film through the treacherous camera, which tempts the director to dodge interpretation and turn them into poetry, hymn, sensuous beauty—anything but plain fact.*[7]

Recently, the American sociologist Howard Becker extended these thoughts in an article titled "Do photographs tell the truth?"

> *In so far as the artistic intention interferes with the photograph's evidentiary use, it does so by affecting the selection and presentation of details, so that some things are not shown, some details are emphasized at the expense of others and thus suggest relationships and conclusions without actually giving good cause for believing them, and by presenting details in such a way (through manipulation of lighting or the style of printing, for instance) as to suggest one mood rather than another.*[8]

Becker is also describing the effect of emotional or political stances on presentations of the thing observed. He went on to point out that "we don't photograph what is uninteresting to us or what has no meaning."[9] The photographer's perceptions are shaped, consciously or unconsciously by his priorities and by his understanding of how his expression of the subject relates to those priorities.

Roy Stryker was in many ways Grierson's American counterpart. For him, the only acceptable priority was social change; his distrust of art with regard to documentary pictures was a source of serious argument between Stryker and the photographers who worked for him at the Farm Security Administration, particularly Dorothea Lange and Walker Evans. Stryker feared that his photographers' desire to make art might take precedence over his own purposes for them. Their task was to document the need in America for additional government relief programs and the achievements of existing programs. If details were to be edited and relationships suggested, Stryker wanted this done for political, not aesthetic reasons, but he was very cautious about *any* overt expression of a theoretical position at the expense of the subject. "The job," he wrote, "is to know enough about the subject matter to find its significance

in itself and its relation to its surroundings, its time and its function."[10] In his view, anything that obstructed or replaced this priority was suspect. At issue were not only the question of which priority should prevail among documentary workers, but also the degree to which the prevailing priority should direct the photographers' perceptions of their subjects.

Documentarians of the radical left were least guarded about their intent to shape and interpret facts to serve their political needs, and political demands strongly affected the factual content of their films. As Richard Griffith noted:

> *Drama and emotion are essential to propaganda, and when it came to a choice, fact was sacrificed in order that the Russian film might remain persuasive.*[11]

The alterations that Howard Becker described were of omission and enhancement, and frequently involved only modest and subtle shifts of meaning. The methods of the left, befitting their goals, involved dramatic alterations of their material. Their goal, explained the American film-maker Leo Hurwitz, was the "creative comparison, contrast and opposition of shots, externally related to each other, to produce an effect not contained in any of the shots, or as filmmaker Samuel Brody has well described it, 'reality recorded on film strips and built up into wholes embodying our revolutionary interpretation of events'."[12] Hurwitz then cited a specific example of documentary montage from a left-wing newsreel.

> *The newsreel shots are sure: President Roosevelt signing a state paper and looking up at the camera with his unimitable self-satisfied smile, and a shot of fleet maneuvers—two shots, taken in widely separated times and places and not essentially (but exter-nally) related to each other. By virtue of splicing the shot of the warships just after Roosevelt signs the paper, and following the threatening ships of war with the rest of the first shot (Roosevelt looks up and smiles), a new meaning not contained in either shot, but a product of their new relation on film, is achieved—the mean-*

*ing of the huge war preparation program of the demagogic
Roosevelt government.*[13]

Hurwitz' example underlines another aspect of the documentary
film and photograph: the importance of context, of how and where the
maker intended the document to be seen. Film clips juxtaposed to form
a montage, photographs placed in sequence on a wall or in a book or
magazine, and images combined with words all function by shaping the
material and directing the response of the audience. The documentary
photographer's duty to his material thus did not stop with the single
picture but extended into its presentation. As Hurwitz noted, the manner
of presenting the whole could dramatically alter the interpretation
of its parts.

Although Roy Stryker's purpose was also to use photographs to
educate and to persuade, he was much more wary than Grierson of using
the term propagandist because, by the end of the decade, the word
became synonymous with the practice of radically altering the material.
"Propaganda" was used to describe the works of the political extremes,
primarily the Fascists and the Communists, and was eschewed by the
political moderates.

The preceding thoughts offer a sample of the divergent attitudes
and intentions that influenced the photographic documentarians such
as Bourke-White, Evans, Lange and Strand in the thirties. Was politics
or art to be of first priority? If politics, to what purpose—civic
participation or revolution? How were these priorities to affect treat-
ment of facts? World events such as the Great Depression, the rise of
fascism and the Spanish Civil War produced a time of chaos and
attendant physical and daily evidence—breadlines, Hoovervilles,
strikes, demonstrations—that was of immediate concern to the artists
and photographers whose work came to maturity in the 1930s. The
chaos was such that it was an act of will for an artist to dissociate
himself and his art from these political and historical facts. Most
artists felt they had no choice. "We didn't abandon our ivory towers,"
said painter Peter Blume, "we were pushed out."[14]

Margaret Bourke-White found her career similarly altered by events
in the thirties. Her work had primarily been advertising assignments and

photographs of business and industry for *Fortune* magazine before 1934, when she was sent to the Midwest to photograph the great drought.

> *I had never seen people caught helpless like this in total tragedy. They had no defense. They had no plan. They were numbed like their own dumb animals, and many of these animals were choking and dying in drifting soil. I was deeply moved by the suffering I saw and touched particularly by the bewilderment of the farmers. I think this was the beginning of my awareness of people in a human, sympathetic sense as subjects for the camera and photographed against a wider canvas than I had perceived before. During the rapturous period when I had discovered the beauty of industrial shapes, people were only incidental to me, and in retrospection I believe I had not much feeling for them in my earlier work. But suddenly it was the people who counted.*[15]

A year and a half after this assignment, Bourke-White closed her advertising photography studio to work on books and for magazines, primarily for *Life*.

Bourke-White's photographs were highly dramatic and appropriate for the magazine audience to which they were directed. Magazine photographs must be readable at a glance, and to achieve that quick assimilation, Bourke-White heightened selected facts. In *Today's Troops, Tomorrow's Officers; Germany, 1932*, she photographed close up, but from a low perspective, so that the single line of soldiers receded to a vanishing point, implying an infinite number of soldiers. The men are not important as individuals, but are used as notations about the rearming of Germany. In *Hamilton, Alabama, 1936*, Bourke-White used the same upward shot to isolate a farm woman against the sky, making the solitary figure appear monumental. Again, Bourke-White reveals little about the specific woman, except that she is young, with lean muscular arms. In the foreground, the eye is drawn to her dry, rough hands resting on the plow. The woman is portrayed as the "heroic worker," a popular image in thirties art.

For Bourke-White, all facts were not of equal value. Objects around the subject that she found inconsequential or distracting were rearranged

to heighten drama, or removed to simplify the picture.[16] When photographing poverty in the rural south for *You Have Seen Their Faces,* a book produced in collaboration with Erskine Caldwell, Bourke-White frequently moved in close and filled the frame with the subject to crop out environmental details that might have offered additional, possibly even ironic or paradoxical, information. If she wanted to evoke a strong emotional response from the viewer, she chose the most exaggerated sample of the condition she sought to convey, and posed the subjects so that the picture would emphasize their ill health, unkempt dress and impoverished living conditions. Even those subjects who maintained their dignity in the photograph elicit the readers' pity through the captions that Caldwell and Bourke-White composed to accompany each illustration. By putting their own words with the pictures instead of the subject's words, and by changing names and places "to avoid unnecessary individualization,"[17] Bourke-White and Caldwell seriously undermined the integrity of the book. Other documentarians were critical of the fictional quotes and were careful in the introductory remarks of their own books to distinguish their methods from Bourke-White's. They felt that she had exploited her subject matter, and that the individuals in *You Have Seen Their Faces* counted only as examples of conditions the authors wished to expose.

For Bourke-White, the need for a dramatically clear, commercially viable picture overrode her obligation to the facts she photographed. Her truths drew more upon preconceptions and popular beliefs than on the reality before her lens; she frequently gave her audience and her editors what they expected to see. In her pictures, facts were presented in the manner a populist politician speaks—lacking subtlety or ambiguity. Robert Capa once said, "If your pictures aren't good enough, you aren't close enough,"[18] but with Bourke-White, the reverse is true. More, not less, information was needed to make her work vibrant and compelling beyond its initial emotional appeal. Her best photographs are those in which the subject is seen directly, from eye-level, and where she lets more of the richness and complexity of the event remain in the picture, as in her 1937 photograph *At the Time of the Louisville Flood.*

At the other extreme within the documentary tradition is the work of Walker Evans. Unlike Bourke-White, Evans did not work for

magazines, but had museum exhibitions and fine art books in mind as the vehicle for his early photographs. His primary audience was literate and literary. His photographs suppress a dominating focus, control surface tension and refuse to dramatize the picture and thereby traumatize the facts. Like a good quilt design, one patch of information might catch the eye first, but the whole surface must be investigated to understand the image. The viewer must identify the structure and analyze the details, appreciating their variety in relation to the whole. In Evans' *Atlanta, Georgia* (1936), the movie poster may first catch the viewer's eye, as the posters were designed to do, but eventually the viewer will notice the houses behind the fence, and then notice that each house is slightly different. Once identical, the houses have weathered variously and have been altered by their owners' modest improvements. The houses, the fence, the posters and the street are rendered with equal clarity. The vernacular architecture stands in understated contrast to Hollywood's touting of its film *Love Before Breakfast,* with Carole Lombard in a sultry, black-eyed pout on the poster. The scene observed reveals itself as a whole with spare, ironic clarity.

In Evans' photographs, the actual is not transformed by heightened perspective or overtly dramatic detail. Rather, there is an overriding demonstration of order; his consistently frontal approach anchors his subjects within the photograph. In this time of political chaos and daily evidence of the Depression, Evans gave an enormous sense of physical stability to what he photographed.

Evans did not share the motive of social protest with Lange, Bourke-White and others, who felt more compelled to respond to the world events of the thirties. "I didn't like the label," said Evans, "that I unconsciously earned of being a social protest artist. I never took it upon myself to change the world."[19] As critic Gerry Badger observed, Walker Evans and Edward Hopper "remained relatively undisturbed by social causes, their personal vision happening to coincide and sympathize with general trends—a basic directness and bleakness echoing perfectly the mood of the time."[20] Evans' photographs have more to do with history than with progress, with record rather than with campaign. His antecedents were Roger Fenton, Mathew Brady and Eugène Atget, rather than Jacob Riis or Lewis Hine.

Dorothea Lange and Walker Evans were colleagues at the Farm Security Administration, and they both published seminal photographic books a year apart. Evans' *American Photographs* was issued in 1938, and Lange's *An American Exodus* in 1939. The difference in purpose of their photographs is manifest in the format of their respective books. In Evans' book, his photographs are sequentially arranged but individually displayed. Each photograph is placed on the right-hand side of a double page spread, with no type on the pages and ample white space around each picture. The carefully organized pictorial sequence is broken into two sections; Lincoln Kirstein's text is printed at the end of the second section. Evans regarded each photograph as singular and complete, with each contributing but not submissive to the larger whole, the book.

In *An American Exodus,* Dorothea Lange's photographs are interwoven with Paul Taylor's text. The book was a collaborative effort from its conception, and every care was taken for the photographs and text to carry the book's message as a visual unit. Lange's photographs are paired and printed with textual passages beneath them on each page. Lange assured the reader that "quotations which accompany photographs report what the persons photographed said, not what we think might be their unspoken thoughts."[21] In addition, brief essays appear at the end of each of the six photographic sections. Pages of photographs outnumber text pages, but the photographs were selected and sequenced in accordance with the flow of the text.

In contrast to Evans' book, *An American Exodus* was not intended to be a showcase for Lange as a photographer; many of her finest photographs, such as *Migrant Mother* (1936), *Damaged Child* (1936) and *Ditched, Stalled and Stranded* (1938), are excluded. Other photographs are cropped to comply with the book's larger themes. In *Filipinos Working in a Lettuce Field, Salinas, California* (1935), Lange photographed from a low angle to silhouette the worker's backs bent against the sky, dramatizing the position of hands and feet fixed to the earth and heightening the viewer's perception of the back-bending labor by making the lettuce rows on which the Filipinos work seem endless. As printed in *An American Exodus,* the photograph was cropped to show the workers without the receding lettuce rows; it is juxtaposed with a photograph of a tractor plowing a field. The *Salinas* photograph is used

to contrast stoop labor and mechanical labor, and to complement the text. The cropping makes *Salinas* a less complex, more graphic picture, which works more succinctly within its two-page unit. In *An American Exodus* Lange's primary goal was to provide convincing visual authentication of points made in the accompanying text. Any value that the images had as art was secondary to the purpose and structure of the book. In reviewing the book, Paul Strand felt that Lange's photographs frequently did "little more than illustrate the text," and he wished for more photographs that had "that concentration of expressiveness which makes the difference between a good record and a much deeper penetration of reality." He regretted that more of Lange's best pictures had not been used.[22]

Lange's and Evans' differences in their use of photography are apparent in the equipment they used and in the size and quality of their photographic prints. They also differed in their regard for and use of facts. Evans' subjects were chosen not for their inherent drama nor for their social significance, but rather as cultural and historical referents, and for the pictorial logic Evans wanted them to satisfy. He assumed that the photograph, like the physical universe it recorded, would have its own internal order, independent of his or his audience's feelings or beliefs. Seeking an intellectual, rather than an emotional appeal, Evans controlled pictorial tension, not the tension between his subjects and the picture's audience. He strove for clarity of representation, not empathy; in not seeking change he supported the status quo.

For Lange, a compelling photograph presented an engaging human drama that addressed questions larger than the immediate subject. Her subjects gained importance from external value systems; she was, by her own definition, a social-documentary photographer involved in the social and political events of her time. "We were after the truth," she wrote, "not just making effective pictures."[23]

She was concerned with the human condition, and the value of a fact was measured in terms of its own consequences. When she photographed natural disasters like land erosion or floods, she focused on how the event translated into human experience and on how she could convey the human suffering inflicted and endured. She had, Beaumont Newhall observed, "a burning desire to help people to know one another's problems"[24] *because*—and this is essential to any understanding of the drive

behind the social documentary movement—she believed that knowledge provoked action, that if people knew about something which required their support, they would act. Lange trusted the persuasive power of information; facts that heightened and directed emotional responses were important. "The consumate need of the thirties imagination," observed William Stott in his book *Documentary Expression and Thirties America* was "to get the texture of reality, of America; to feel it and to make it felt."[25]

Today, the subjects of Lange's pictures are, as Therese Heyman has observed, "figures in history whose hardship the present viewer is incapable of easing—symbols of timeless sorrow."[26] Present day viewers are not action-oriented reformers seeking clarity of issue, but search instead for irony and haunting eloquence. Pictures with these elements are found in the body of Lange's work, but it is important to understand that she chose not to publish them during the thirties. Because they did not carry a persuasive message, presentation of these pictures was deferred until her retrospective exhibition *as an artist* in 1966.

Paul Strand is another photographer whose work shaped American documentary photography in the 1930s, although during the last five years of the decade he was primarily a filmmaker. He was thirteen years older than Evans and Bourke-White and five years older than Lange, but he had established his reputation almost twenty years earlier than they, in 1917, when Alfred Stieglitz published Strand's work in the last issue of *Camera Work*. Walker Evans wrote that "the effect [of that issue] was breathtaking for anyone interested in serious photography, or in pictures, for that matter. Seeing it was a strong enough experience to energize on the spot any young camera artist with bold aesthetic ambitions."[27]

In their use of high drama, Strand's photographs were closer to Lange's and to Bourke-White's than to Evans', but they were more monumental, more artful. Strand's work was never without the aesthetic pleasure of commanding craftsmanship and formal beauty that belies his debt to Alfred Stieglitz and modern art. He felt an obligation to factual truth, and wrote that "a photographer must develop and maintain a real respect for the thing in front of him."[28] However, he also responded to truths expressed through beauty and classic form. "There is a strong element in Strand's photographs of sympathetic identification with the

subject matter," wrote *New York Times* critic Hilton Kramer, "but the overriding impulse is toward aesthetic confinement."[29]

Without sacrificing the delicate details of photography's infinite tonal range, Strand heightened certain facts over others. While Evans and Strand shared an overriding demonstration of order in their pictures, Evans avoided the vivid sunlight and deep recess of shadow that Strand employed to heighten emotional intensity. Evans succeeded in making his prints seem artless, so that the viewer is unconscious of the photographic process. By contrast, Strand's command of his craft forced audiences to look at, and hopefully then to understand, something fresh about their world. He brought dramatic and total command of formal and tonal richness to weathered wooden planks, a child's shawl, a frozen but eloquent gesture. The beauty of the print, as much as if not more than emotional engagement with the subject, made the viewer acknowledge its importance.

Strand was a political moralist, but as the English critic John Berger observed, Strand's social protest was so sweeping that it could not be made directly by illustrating any single dramatic incident.[30] Despite his ardent political views, Strand's still photographs were neither newsworthy nor useful as propaganda because, unlike Lange or Bourke-White, Strand did not portray social conditions that needed repair. Strand was more intent on rendering the eternal than the temporal conditions of man, "the basic truths of man's relationship to the world and to his fellow man."[31] Through 1934, and after 1943, the facts Strand respected were those that defined a place for all time. He said, "I've always had an interest in things that make a place what it is, which means not like any other place and yet related to other places."[32] The photographs Strand included in *The Mexican Portfolio* are marked as Mexican by the thickly woven work clothes and brightly patterned serapés, by the baroque religious architecture built of simple materials but dramatically rendered in strong sunlight and shadows, and by the bultos of saints and virgins made "poor and dark and humble, like ourselves"[33] by the peasants who worshipped their own blend of the Catholic religion and ancient Indian idols.

If Strand's still photographs eschewed specific social conditions for basic truths, as a filmmaker he bent "with the gusts of social pressure."[34]

In 1937, with Leo Hurwitz, Ralph Steiner and others, Strand founded Frontier Films. Then, reported Robert W. Marks, "Strand stepped out of the ivory sanctum, filled his hands with fresh earth and set about building breastworks."[35] In the next five years, Frontier Films produced anti-totalitarian documentaries dealing with events in China, Spain and Czechoslovakia and a feature-length dramatization of civil rights violations in America. In these films Strand responded to the broad, rending social issues of the thirties by advocating social and political change.

Labeling these four photographers of such diverse style and intention with the term documentary identifies each with the tradition that accepts the photograph as a factual report. Yet the similarity is tenuous when their radical stylistic differences are analyzed, and in these differences are found the limits and distinctions of the term as it evolved during the 1930s.

Each photographer felt obligated to make honest records of the facts he or she photographed. Evans was the most rigorously formal, and for him, the subject itself was the final authority. He did not regard the subject in a way charged by emotions or extreme values, especially political values, but regarded himself as an artist. When he chose a collaborator, it was either a writer like James Agee or a brilliant patron of the arts like Lincoln Kirstein.

Paul Strand also regarded his pictures as art. Although he held ardent political views, the artistic priorities, in his still photographs at least, remained dominant. Strand never put his still photographs in a social framework that would compromise their seriousness as art. His only exhibitions in the thirties were at Stieglitz' An American Place and at the Sala de Arte in Mexico City; his only publication was the limited edition gravure portfolio of twenty of the Mexican photographs. Strand preferred to collaborate with other artists, or with an art historian. Strand and Evans shared a matter-of-fact quality in the impersonal nature of their art and their refusal to let their subjects appear overwhelmed by life's forces. If Strand wanted to express the violence of life, he did so symbolically through the twisted forms in nature.

Margaret Bourke-White was the only one of these photographers for whom a commercial career was paramount. What political convictions she held never interfered with her career, and as a journalist she was

more inclined to expose than to reveal. The pity she expressed for the victims of the great drought in 1934 she continued to feel for people caught and overwhelmed by social forces. She expressed it in the blank faces of the Buchenwald survivors and in the sweaty, dark existence of South African miners. In her pity, she was distinct from the others; and very unlike Strand, she found a beauty in faces that "no amount of oppression could destroy."[36]

Only Dorothea Lange was completely committed to social documentary photography and to effecting social change through her art, and she was successful to some degree. The report Taylor and Lange submitted to the government on destitute migrants harvesting in the Imperial Valley, for example, resulted in an appropriation of $20.000 to establish a migratory camp. Lange alone chose as her collaborator a social scientist rather than an artist, novelist or art historian. Both in her photographs and in her terse informative captions, she was assiduously faithful to actuality, but always in terms of its human consequences. Her images, more than any others, have become icons of the renting social issues of thirties America.

NOTES

1. Forsyth Hardy, Introduction, *Grierson on Documentary* (New York: Harcourt, Brace and Company, 1947), p. 4.
2. Hardy., p. 20.
3. Richard Griffith, "The Film Faces Facts" *Survey Graphic* 27, no. 12 (December 1938), pp. 595-600.
4. Griffith, p. 596.
5. Griffith, p. 598.
6. Beaumont Newhall, *The History of Photography* (New York: The Museum of Modern Art, 1982), p. 238.
7. Griffith, pp. 597-598.
8. Howard Becker, "Do Photographs Tell the Truth?" *Afterimage* February 1978), p. 12.
9. Becker, p. 12.
10. Roy E. Stryker, "Documentary Photography" *The Complete Photographer*, no. 21 (1942), p. 1372.
11. Griffith, p. 597.
12. Leo T. Hurwitz, "The Revolutionary Film—Next Step" *New Theatre* (May 1934), reprinted in *The Documentary Tradition: From Nanook to Woodstock,* ed. Lewis Jacobs (New York: Hopkinson and Blake, 1971), p. 92.

13. Hurwitz, p. 92.
14. Elizabeth McCausland, "Artists Thrown into World of Reality Present Their Cases" *Springfield Democrat and Republican,* (March 1, 1936).
15. Margaret Bourke-White, *Portrait of Myself,* (New York: Simon and Schuster, 1963), p. 110.
16. Bourke-White, pp. 126-127.
17. Erskine Caldwell and Margaret Bourke-White, *You Have Seen Their Faces* (New York: Modern Age Books, 1937), no page number.
18. Anna Farova, ed., *Robert Capa,* (New York: Grossman Publishers, 1969), no page number.
19. Walker Evans, "The Thing Itself Is Such a Secret and So Unapproachable" *Image* 17, no. 4 (December 1974), p. 14.
20. Gerry Badger, "The Modern Spirit—American Painting 1908-1935 at Hayward Gallery, London" *The British Journal of Photography,* (November 4), 1977, p. 641.
21. Dorothea Lange and Paul Schuster Taylor, *An American Exodus: A Record of Human Erosion* (New York: Raynal and Hitchcock, 1939), p. 6.
22. Paul Strand, *"An American Exodus* by Dorothea Lange and Paul S. Taylor" *Photo Notes,* (March-April 1940), p. 2, reprinted in *A Visual Studies Reprint Book* (Rochester, New York: Visual Studies Workshop, 1977).
23. Nat Hery, "Dorothea Lange in Perspective" *Infinity* (April 1963), p. 10.
24. Beaumont Newhall, "Foreword" *Dorothea Lange Looks at the American Country Woman* (Fort Worth: Amon Carter Museum, and Los Angeles: Ward Ritchie Press, 1967), p. 5.
25. William Stott, p. 128.
26. Therese Thau Heyman, *Celebrating a Collection: The Work of Dorothea Lange* (Oakland, California: Oakland Museum, 1978), p. 81.
27. Walker Evans, *Quality: Its Image in the Arts,* ed. by Louis Kronenberg (New York: Atheneum, 1965), p. 178.
28. Alden Whitman, "Paul Strand, Influential Photographer and Maker of Movies, Is Dead at 85" *The New York Times* (April 2, 1976), p. 36.
29. Ibid.
30. John Berger, "Painting or Photography?" *The Observer Weekend Review* (London), February 24, 1963, p. 25.
31. Photo League brochure, Fall 1948.
32. Calvin Tomkins, "Profile" *Paul Strand: Sixty Years of Photographs* (Millerton, New York: Aperture, 1976), p. 23.
33. Anita Brenner, *Idols Behind Altars* (New York: Biblo and Tannen, 1967), p. 155.
34. Robert W. Marks, "Portrait of Paul Strand" *Coronet* (June 1939), p. 165.
35. Marks, p. 175.
36. Walter Rosenblum, "Paul Strand" *American Annual of Photography* (Minneapolis, 1951), p. 12.

# WALKER EVANS' AMERICA
## A DOCUMENTARY INVENTION

*Alan Trachtenberg*

> *It's as though there's a wonderful secret in a certain place and I can capture it. Only I, at this moment, can capture it, and only this moment and only me.*
>
> WALKER EVANS

> *Reality is a construction.*
>
> SIEGFRIED KRACAUER

When Walker Evans' *American Photographs* appeared in 1938, reviewers assumed at once that the pictures represented a real and demonstrable America. "The photographer has put us on record," wrote Pare Lorenz in the *Saturday Review*. "If everything in American civilization were destroyed except Walker Evans' photographs," Carl Van Vechten observed, "they could tell us a good deal about American life." "Taken in the Eastern part of the United States during the past seven years," William Carlos Williams remarked in *The New Republic*, the pictures are "a record of what was in that place for Mr. Evans to see and what Mr. Evans saw there in that time." Indeed, so manifestly did an exterior world seem, to the early reviewers and to most viewers since, to impress itself upon this artist, shaping, molding and exhaustively filling his pictures, that style, technique and pictorial

form seemed irrelevant, hardly noticeable. "The composition is of secondary importance in these clear statements," Williams noted; "their type of beauty permits little of that."

The only distinction that seemed to lie in Evans' ability to make such clear statements was an apparent lack of distinctiveness, a determined refusal to intervene in the picture's mediation of an exterior world—a refusal, that is, to signify that an intervention had taken place. Impersonality, transparency and purity have remained perhaps the most commonplace terms of both description and appreciation in critical treatments of Evans' work. Striking the keynote early in Evans' career, Williams speaks of "a straight puritanical stare," and Lincoln Kirstein, in the essay included in *American Photographs,* of "the rigorous directness of its [Evans'] way of looking." That directness—the famous frontality of Evans' point of view and the flat evenness of his picture-plane—has seemed virtually an anti-style, indeed, in Kirstein's words, a profoundly "antigraphic" element. Kirstein proposes we think of Evans less as a photographer than a record-keeper. And Williams, putting the same thought more suggestively, writes that the pictures in *American Photographs* "particularize." "By this the eye, and consequently, the mind are induced to partake of the list that has been prepared—that we may know it."

This view of Evans, and of *American Photographs*—that he prepares a list of particulars, that he inventories a "real" America—has remained more or less intact. "Individually," wrote John Szarkowski in 1971, "the photographs of Walker Evans evoke an incontrovertible sense of specific places. Collectively, they evoke the sense of America." To be sure, "evoke" leaves unsettled the question of whether Evans merely recorded his incontrovertible America, or made it up. It equivocates, that is, about origins. Nevertheless, Szarkowski writes, "whether the work and its judgment was fact or artifice, or half of each, it is now part of our history."

We continue to think of *American Photographs* as a sourcebook, circa 1930s, of American reality: a piece of our collective history. But is *American Photographs* in fact a transcription of an incontrovertible America? By raising the question I do not mean to cast doubt on the book's claim as an essential integer in our history of the era of the Great

Depression. But I do want to cast serious doubt upon the notion that the book earns its place in our collective memory as an inventory or transcription of a presumed reality. Being photographs, of course, the pictures in *American Photographs* do bear a special relation to their subjects; they do inform us, at one level of understanding, that a photographer and camera were indeed *there* at a certain time. But the there of the camera's place and the there of the book are quite different locations; different not only in place, but in kind of place. One is an actual physical site, where a shutter was released and a photographic exposure made; the other is an immaterial place, a physical book to be sure, but still, a place to be made up by the reader-viewer in the course of experiencing the book.

I want to reconsider the book's relation both to its apparent subject, the here-and-now of its original places or sites of exposure, and to its putative subject, the America those separate here-and-nows are assumed to comprise. Let me make it clear that by "reconsider" I do not mean to introduce a question of accuracy or correspondence between the collective effect of these pictures and any other account of the life of American society in the same years. I hardly mean to say that Walker Evans was either right or wrong in his picturing of that life, or even to suggest that such terms have any validity or interest in a serious discussion of the book or of the category we call "documentary" photography. I want to reconsider the book's relation not so much to an America that might be said to have existed in certain determinate and discernible forms, but rather to an idea of America, an idea of how or where an America might be located and identified within the book itself. By an idea of America, I mean an idea regarding the status of the term, the place or the site, the *locus in quo* of America. The question of whether the book discovers or invents, whether it transcribes or creates, depends very much on what kind of reality we take the book to be representing. Of what, finally, are these pictures documents?

The question of the site and the status—of the place of America in *American Photographs*—is inaugurated at the outset by the very title, by its tacit acceptance of an ambiguity: is "American" an attribute of the subject or the object of "photographs"? Are the photographs American in that they are "of" (in some simple sense of transcription) an

America (the name thus designating a specific place)? Or in that they themselves possess an American character, a style or manner, an inscriptive quality, that conveys Americanness? In short, the indecision of that title injects a doubt. Is America a material or an imagined place? Does it lie somewhere on the other side of the pictures, in a space shared with the camera, or does it lie *in* the pictures, coterminus with the photographic act itself, a product of the camera? Did Evans see it, or make it up? Or, indeed, as Szarkowski suggests, both? And if both, in what proportions? Is there a discernible line marking a boundry between the real and the imagined, a point at which we can say one turns into another, where an America of fact becomes—perhaps realizes itself as—an America of Evans' artifice, an artifice whose leading attribute (though in what sense we cannot yet know) is its Americanness?

From the very beginning the pictures acknowledge ambiguity; particularly in the opening sequence of the book, they acknowledge a problem in their own subject, the problem of what a book titled *American Photographs* might be all about. "The pictures talk to us," writes Williams. "And they say plenty." They say plenty, moreover, about themselves, about the kind of pictures they are and the sort of work they perform. Our reconsideration of the book as a document, indeed as a *locus classicus* of documentary photography in America, requires that we look as rigorously as possible at the pictures themselves, that we hear especially what they have to say about themselves—that we read them as texts.

They are, of course, texts within a larger text, within a book. What the pictures say they say in relation to each other; the full voice of each image is released only when we leave that image behind in quest of the next, the following and finally all following images in the book. What they say they say in and through the relations among the totality of images which constitutes the book: the book itself finally constituting the meaning, the speech of the pictures. Rather than merely a way of presenting a group of pictures, the form of the book draws the viewer-reader into a process of unfolding, a developing discourse of continuities, echoings, doublings and cancellations, revisions, climaxes and resolutions. Each picture completes itself only in the complete work, its voice returning to it as an echo of the whole. The process is cumulative, with implications gathered and strung together at each successive passage

from one image to the next. We partake, then, not only of a list that has been prepared, but in the making of that list, in the preparation itself, the ordering of images.

For what the book places in order is precisely a domain not of things as such, of unequivocal objects in the world exterior to the camera, but of *images,* things already in the condition of image, of representation. In its critical opening sequence, the first six pictures, the book declares the making, status, social ramifications and actions of the image to be at least one of its subjects, what it meditates upon while in the act of performing that very theme: making and instituting images. How that subject—the images of things—stands in relation to the subject of America as a specific (and historical) order of things—is among the questions framed by the opening sequence.

Taken as a group, the first six pictures institute a set or pattern of relations that is repeated and echoed throughout the book. The most commanding of these relations seems to be the relation among kinds of portrayals or representations: viz., the photographs in 2 and the drawings in 4 and 5. To say only that photographs are thus brought into a relation of contrast (providing an effect of irony) with hand-produced, idealized representations falls short of the actual complications that unwind as we continue to look and question. Consider, for example, the fact that of the six pictures, the inner four—2, 3, 4, 5—present in one version or another images or representations of people, while the outer two, 1 and 6, are empty of people, in fact or in image. (This is not entirely true of 6, in which the newspaper on the rear wall shows people in several reproduced photographs that are more or less inconspicuous in the picture.) If the six images comprise a sequence, self-sufficient though integral to the book as a whole, what relation subsists between 1 and 6, as well as among 2, 3, 4, 5? And in what sense can we say that 1 and 6 relate to each other *through* the others, that we arrive by a credible logic from 1 to 6 only by going through and accumulating implications from 2 to 5?

We proceed by successive recognitions. 6 shows the interior of a barbershop; 1 the exterior of a kind of photo studio. Exterior/interior, we will discover, is a recurrent relation throughout the book, as it is in opening sequence. 1 and 6 stand in a relation of contrast, of difference. Yet we note a tantalizing symmetry. 1 is followed by a picture that

demands to be taken as an instance of a kind of activity performed *within* the structure that we see only as an exterior in 1—that is, the penny-pictures of 2 can be seen as the product of a process only signified in 1. Here, product follows process; but the relation is reversed in 5 and 6. In 5, the woman in the doorway of the French Opera Barber Shop discloses in her appearance what might be taken as a product of the labor performed in an interior such as that portrayed in 6. Now these relations are not exact, yet the form of symmetry holds; for if the lady's blouse, a duplication of the front (the exterior) of the shop, is a comic wink at the process of change occurring inside the shop, it proclaims that process as one of change of *appearance,* a making-over into *image.* So too, the products of the photographic process in 2 disclose persons made over into image, into *picture.* And what kind of picture is made concrete, particular and definite by contrast with the kinds of pictures in 3, 4 and 5 (and less conspicuously, in the sideway-lying newspaper portraits in 6).

The pictures posted on proof-sheets under a glass window inscribed with the stenciled word STUDIO are not the approximation of an appearance true of the Hoover picture in 4 or the girl in the ad in 5. They are exact reproductions, identical in size and framing, obviously and unembarrassedly machine-made. Direct, unassuming, they present in their grid-like form a kind of cross-section of faces, of people presenting themselves to the mechanical eye of a penny-arcade camera, free only to adjust their appearances within the framed space allowed them. Devoid of signs of high-art intention, they are emblems of mechanical stylelessness. Indeed the signs of a true transcription and surely the kind of images produced by the kind of establishment pictured in 1, they are here appropriated by the maker of *this* picture (Evans), who makes a picture in an act of wit and wickedness by allowing his own camera to frame the original transcriptions, thus releasing new meanings from the inscribed sign STUDIO.

But why is 2 followed by 3? The relation here begins to clarify the direction of the sequence 1-6, to articulate its design. For 3 at once announces a radical difference from 2, in so far as 3 is not a picture of pictures but of people. We are struck instantly by a difference in style as well. These faces are not mugging into a camera in a studio, but are caught unawares on a street. The figures wear their daily work-clothes,

1

2

3

Photographs by Walker Evans from *American Photographs*. Courtesy the Walker Evans estate. 1. *License-Photo Studio, New York, 1934*. 2. *Penny Picture Display, Savannah, 1936*. 3. *Faces, Pennsylvania, Town, 1936*.

4                                 5

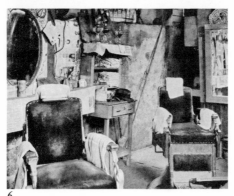

6

Photographs by Walker Evans from *American Photographs*. Courtesy the Walker Evans estate. 4. *Political Poster, Massachusetts, 1929*. 5. *Sidewalk and Shopfront, New Orleans, 1935*. 6. *Negro Barber Shop Interior, Atlanta, 1936*.

not their Sunday best. Moreover, the space of the picture is of a kind drastically different from that of the penny-pictures. The two faces and torsos stand forward in clear focus against a softly-focused background of blurred faces. This relation challenges the grid pattern of 2, in which each image, confined to its own studio space, is both isolated from and equal to every other face. The difference in relation between fore-grounded figures and background in 3 makes the photos in 2 seem, in their standardization, official identification pictures of the sort implied, after all, by the "license photo studio" of 1. Beneath the mechanical anti-style of the images depicted in 2, then, lies an official function of photography—identification—and an implied theory of the camera as a final arbiter of identity, an authority over the definition of reality. This implied authority, furthermore, is associated especially with the most mechanical version of the photographic act: The penny picture machine, the auto-license photo producible in five minutes. What seem, then, to be overture-like images in 1 and 2 that inaugurate the enterprise of this book by linking Evans and his camera with that of vernacular photog-raphy, assume, in the flow of the sequence, considerable ambiguity.

Number 3 detaches itself from the implied theory of the authoritative (and supervisory) camera of 1 and 2, in yet another striking and revealing treatment of the picture-space. The camera captures and frames the two young men as each is in the course of an action, the visual attention of each drawn sharply across the front of the picture plane to something beyond the frame itself. Tightly-composed, the figures thrust themselves, by their attention elsewhere, against the restraint of that frame. Along with the differential focus, this produces the effect of confirming the presence of a camera performing arbitrary acts at the behest of its manipulator, the maker of the picture. The picture thus calls attention to itself as an act of picturing, of framing by deliberation and without reference to a universalism, an authority implied by the fixed camera focus and position of the penny pictures and the license photos.

Moreover, it is significant that 3, the picture in the sequence which presents the photographer picturing a previously unpictured world, a scene without internal pictures, is also the sole image in the sequence without an internal frame, a frame within a frame, such as the dark doorway in 1, the many frames of 2, the framing window panes in 4,

the doorway in 5—and the mirrors in 6. The absence of the inner frame gives all the more force to the picture's outer-frame, its edge, as a sign of the photographer's own work of construction, the intervention of his camera.

In the opening sequence of *American Photographs* we have, then, what seems a pointed discourse on the photographic image, or more particularly, on the character of *these* pictures, Evans' American photographs. By contrast and differentiation, the opening pictures insist that the camera is an instrument of construction, not mere transcription; that it plays a role in the making of the world it depicts as image. The book opens, then, with an unequivocal break with the notion of an infallible camera and a transcribable America. The frame—what it excludes, what it compels us to imagine as outside its limits—serves as the maker's inscription, the signature of his own performance. Moreover, the sequence underlines this activity of a transformative making, as opposed to the passivity of a mere mechanical copying, by associating the work of the camera with the work of the barbershop, with the making of appearances, of self-presentative forms, and by extension with all the forms of labor and craft represented throughout the book. Especially in the second part of the book, signs of craft and of skilled hand-labor clash with signs of machine-production and with images of mass reproduction of standardized objects. Containing memorable images of hand-hewn churches and dwellings, Part Two associates craft and making with religious forms, with communal functions. The two relics which enclose Part Two are stylized representations, in metal, of natural forms—the tree still present as the origin of the classical column in the first, and the swirl of petal and flower in the roseate of the final image. Each represents a transformation, a generic act of which all craft partakes, and one with which Evans unmistakably associates photography. It is the instrument of capture and delivery, through the highly-inscriptive mode of the closeup, which transforms objects into "relic," a remembrance, a memorial, a surviving trace after a destruction or wasting away.

The function of the opening sequence is to make visible the craft of the book itself. Epitomizing the book as a whole, the opening six pictures insist on the inscriptive rather than transcriptive aspect of the camera, on its service as a kind of pen or pencil, an instrument of a kind of

writing. Thus, in 1, the doubled, hand-drawn hand pointing in the direction of the entrance to the studio is appropriated as a mark of the photograph itself, not merely as a pointer to what pre-exists in the world, but as a sign of the hand-work of *this* photography, the performance of framing this particular scene, of bracketing its signs as ambiguous emblems of a different enterprise. The pointing fingers, like the hand-scrawled messages filling the space surrounding the hand on the left, testify to the persistence of hand, of craft, of inscription.

The opening sequence establishes, then, the formal structures through which the book proceeds in its construction of an imagined America, a place of a particular history (e.g. Hoover), and of cultural themes represented in repeated emblems: automobiles, gender relations, race, war, patriotism, community, isolation, loss, ruination. "The total effect," wrote William Carlos Williams, "is of a social upheaval, not a photographic picnic." The book is difficult, "not entirely easy to look at," as Kirstein remarks. Evans' America is not a finished place, but a series of acts, of gestures toward the making of a place. There is no immanent whole here named America, but a meditation on perception and on the making of reality, on the character of images and on the sufficiency of art. The art arises from the craft of photography, the craft of mechanical transcription, of documentation, but it goes beyond that. The documentary mode, of exact reproduction for the sake of conveying the look of things, is only a means here; the end is the making of a fictive world, an America of the imagination: a documentary invention.

# A WAY OF SEEING AND THE ACT OF TOUCHING: HELEN LEVITT'S PHOTOGRAPHS OF THE FORTIES

*Max Kozloff*

Modern street photographers are fluttering, intrusive, yet vaguely stealthy creatures who live on edge in quizzical search of imagery they cannot foresee. They have reason to be nervous, for they work in a chaotic zone of ephemeral "targets" that may be reluctant to appear in the unannounced view, or else are endowed with a speedy, unsettling talent for vanishing from it. But this visual quarry teases not simply because it is disobedient and elusive. The conditions of the field are more bothersome than that, for the motifs presented by the photographer cannot be said to have existed before, and they do not endure after they have been wrought from light in the precise configurations that we later come to know.

To walk the streets is to be confronted with a stupid abundance of confused, jostled and small incidents. The photograph will fix any instance of it with a drastic particularity, wispy, random and, therefore, perhaps trivial. How is the stuff of the image transmuted into a message? How, even more, can its sensations be made to *represent* a view of life, especially since they often pulsed so obscurely and subliminally as to have left little impression in the blur of original contact?

Yet in an archaic sense, photographs predispose us toward what they show, if only by virtue of having uniquely extracted it. I can't help reading a picture as a preferred view, although, without further support, it could only be a gratuitous one. If I am to be *swayed* by a photograph, it must enter culture and be assigned mutually enhancing relationships with its

own kind. That desirable state, for all serious photographers, is embodied in the problem of recurrence, of recurrent imagery.

On one hand, recurrence, as a picture-making strategy, works as a form of corroboration of data, themes or attitudes spread through large arrays of images. On the other hand, recurrence simplifies the stylistic and conceptual demands imposed by a pictorial mode that is basically atomistic in its characteristic results. Raw material is acted upon, approached and edited to suggest the illusion of an emergent pattern of scattered events. From mysteriously determined points, we catch glimpses of comparable details in disparate scenes and similar manners from separate milieux. There is a psychological link between the phenomena of recurrence and notions of the essential. When it is recurrently embroidered by street photography, the momentary can begin to look momentous. We find ourselves thinking that that is how people really are or what they archetypally do. I need hardly add that most books of photographs are iconically unified through their homogeneous depiction of *classes* of things or scenes. Often, their very topic defines the limits of treatment and typifies a genre, as currently understood.

But the street aesthetic meshes more delicately with these organizational traits because it asserts itself precisely by being on the loose, artistically independent of media directors. The mobility of street photographers, however, does not necessarily lead them to the fictions of the art world, nor do the photographers seek legitimization there. They are in flight, rather, from the stereotypes of photography for hire. The freedom at issue is not so much to allow the photographer to be personal for the ego's sake, but to use the ego to describe intimate and fortuitous realities not otherwise available.

Practitioners of street photography ideally treat a specific class of events, though it is an untidy one that permits an extremely wide assortment of subjects. It belongs to a type *least* tainted by the photographer's presence. Underlying street photography is a naturalist argument that goes something like this: The value of the picture resides in its truthful observation. This value is jeopardized to the extent the photographer intervenes in the social circumstances, causing a rupture from what would naturally have happened. The natural is defined as a melange of urban events contingent upon each other, and therefore inherently effer-

vescent and unpredictable. There can be no record of such action unless the photographer is committed to techniques of furtive and opportune surveillance whose goals cannot easily be rationalized. No wonder street photographers are often solitary, and always professional strangers with little to say about their indefinite motives. Still, their overall approach is conceptually articulate, because in practice it integrates the moral goal of credibility, the philosophical notion of contingency and the professional requirement of freedom and spontaneity, each impossible to realize without engaging with the others.

Although a photography of the streets gradually emerged about a generation after the medium itself was born, the particular variant I have just described dates only from the 1930s. The hectic urbanism of the West could not fail to have been documented by the camera. They were mated with each other as if by industrial contract, and the products of their working union gave innumerable visual records of metropolitan growth, density and manners. Whether generally accessible or not, such records, particularly those from the 19th and early 20th centuries, are thought to contribute to a public archive whose constituent parts are understood to be representative of given themes. But the themes themselves cannot be said to be resolved, apart from the ways in which images have been compiled and their possibilities inventoried. This traditional organizing scheme gives priority to the idea of finite, typical variables that can be classified, as distinct from the infinitude of non-repeating events that may be placed on several disparate lists, never to be filled in. This newer, more difficult alternative, although sometimes incorporated into archives, presented itself about fifty years ago in the work, for example, of such people as Henri Cartier-Bresson (whose photography had the earliest international influence), André Kertész and Ben Shahn.

If these street photographers certify that nothing more is seen or even meant than what is shown, they offer concrete findings without any journalistic pretext. More curious about the actual processes of the visual flux than in the debatable causes or outcomes of specific actions, they display a useless respect for their environment. Before there is any judgment in their outlook, it has to have momentum, a powerful drive to the sheer act of looking. Afterward, the providential disorder of the images is structured and encompassed by the conscious sensibility of an indi-

vidual. Instead of scenes rendered transparently by an impassive camera (for a known social purpose), we have a photographer's actively filtered world, or even an emphasis on how a pronounced *photographic* concern transforms the material of the world. Cartier-Bresson's 1953 *The Decisive Moment* was a summary of well over twenty years of effort on this level. It was the first conclusive book of its type, but could have been preceded by Helen Levitt's mettlesome *A Way of Seeing*, ready in 1946 but not published until 1965![1]

Helen Levitt is a quintessential modern street photographer, and to consider her early work is not only to see how the mode can be animated, but to come close to the moment when it was actually created. Compared to previous titles such as *You Have Seen Their Faces* (Margaret Bourke-White, 1937), or a later one, such as *The Americans* (Robert Frank, 1956), Levitt's *A Way of Seeing* has a flat, non-leading tone, asserting only the relativity of her vision. In contrast to the project-oriented work that surrounded it, the book, which had forty-four uncaptioned photographs in the original edition, promises very little and deliberately refuses to be fit into any category. It could have been called "New York Summers," or "Street Kids," with a dismal explicitness that would have foreclosed its true scope and real poetry. The sense of the book is staked on its "way" ... the qualities of its regard. At the same time, and this is its particular tension, the matter of the pictures wins out over their manner. One cares about her subjects because the photographer makes us feel they are seen with a caring eye. It is as if they had to be envisioned by her artistry so as, in the end, to become representative, not of any pre-determined state of affairs, but of themselves.

Helen Levitt, a predictably circumspect and private person, wary of publicity, says that she does not envy anyone who has the hard task of verbalizing about her images. She clearly was not referring to any imagined complexity, but she could have been thinking about their unassuming directness. We're far more familiar with that stance now than was James Agee, who was startled by it when he wrote a remarkable essay for *A Way of Seeing* in the mid-forties. He had not expected that her off-hand framing could have conducted such volatile and lyric energy.

What attracted that energy at first looks superficially like what once drew Lewis Hine to scrutinize the lives of deprived children. In Hine's

output, one is struck by the feeling that too much wisdom, and too much hardship of the kind that instills such wisdom, has been imposed by a harsh environment on those too young to absorb what it means. Their innocence is eerily stunted. Hine's children are at work, or they pose in the workplace, a hellish community in which they've been burdened far too soon by callous bosses and an indifferent society. For their part, Helen Levitt's youngsters, involved in play, are small, explosive parentheses on weary and alien streets. The good cheer, if not the festive savagery of these juveniles, is touchingly out of place. Levitt has in common with Hine a grimy, earthy view of the urban background, but she does not elaborate upon it as material distress. What he reported were "conditions;" what she discovers are nuances.

Instead of building up concrete particulars over and over with each page to give a uniformly dense portrayal, Levitt's book proceeds by way of uninsistent modulation in loose thematic clusters, taking our attentiveness as if on a stroll through a variety of slight urban gestures and expressions. That is why, in talking about her children, I have already speculated too much about the book's meaning and said too little about its actual content. For it depicts not only the sputtering charades of black kids and white ones, but the kibbitzing of their elders, graffiti and the loafing and hugging that goes on among family and friends with time on their hands during the dog days of the New York summer.

From this composite of unlike but naturally related situations, no one emphasis declares itself sufficiently to be read as centrally important. To questions of whether this is an album chiefly about an urban season, about how streets are populated by their communities, the sociology of ghettos, the fantasies of children, or the way parents and their offspring deal with each other, the photographs frequently answer yes and no at the same time. Or rather, the whole range of these topics can be made implicit in individual pictures, lightly, though, and strewn about.

In retrospect, it's clear that by her choice of visual territory and her rapid traverses through it, the photographer foresaw that such interests would ordinarily overlap. And, once again, while we accept overlapping social fluidities in photography today, they were by no means the rule in the late 1930s, when Helen Levitt set out to explore the neighborhoods of her city with a second-hand Leica.

The public life of New York, for a century, had been represented as the dynamic accumulation of innumerable *historic* events, typifying acts and progressive stages, unfurled in collective witness by a chorus of anonymous specialists. Profiled against this simple and heroic version of modernism, there emerged the humble, problematic and apparently de-flating modernity of generalists like Helen Levitt. They took on for themselves the role of individual witnesses whose experience taught them that the city was a jumble of diverse sensations in which they, themselves, had to swim. Nowhere was this reality of the miscellaneous, this field of simultaneous and non-exclusive accents, more available for study than on the street, a setting for the urban mass along whose reaches unsuspect-ing private conduct mingled with more self-conscious behavior. Their broad but unceremonious concept of the street marked off photographers like Helen Levitt from their corporate brethren. Suddenly it became unclear what such people were looking at.

For good reason. Instead of social hierarchies and history, these photographers took in only phenomena through their eyes—the phenomena of a decomposed present, with all its immediacy and obscu-rity. Where random glimpses appeared with intermittent frequency be-fore, they now became a constant feature of photographic operations. The result was a far more democratic panorama of multiple happenings, stumbled upon, as it seemed, by pedestrians whose limited vantage and unbiased survey would correspond with our own, in like perspectives. More authenticity of viewpoint was gained at the cost, however, of greater uncertainty of content. It only remained (but what an *only!*) for a photographer with depth and insight to make sense of the variables that gushed in the field.

If, as I realize, I've encouraged a view of street photography as a canon of busy forms and diffuse possibilities, I must now state that Helen Levitt's street images are extraordinarily terse. She implies but does not demonstrate that New York is a populous place. She suggests but does not spell out the eruptive power of a crowded underclass. The most talkative element in *A Way of Seeing* is the key fact that most of its pictures were taken when it was hot in New York, often swelteringly hot.

We know this, not only because of the lightness of people's clothes and the oppressive glare of the sun, but through those many frames in

which the younger subjects try vainly to cool off at open hydrants or from passing sprinkler trucks. These are the book's most dramatic moments of sport, and they symptomize its expressive drives. Unquestionably, the spewing, graceful water acts as an image of desire, but more importantly, the memory of it carries over to many other districts to evoke, in the gaming we see there, the idea of primal instinct being released, or liberated, *under pressure.*

This binary process seems reflective of the photographer herself. Always, the purely visual intelligence of her photographs yearns for concision, intimacy and, as a result, the strong, disjointed isolation of episodes from the indefinite mass, while, with equal force, a social instinct wants to hold in view the affective ties that people have with each other, their expansiveness and their sense of community. In the summer, or at most during the warmer months—the only time when Levitt will work the streets—emotions are proverbially short-fused. It is the season of small but incandescent contacts which rise up in such brief, wired flares that to have caught them at all the photographer must have flown off the handle and held her breath, all in one act.

The steamy compression of their East Harlem apartments had flushed people out into the streets, where they congregated in front of their stoops and doorways, conversed in dialogue between windows and sidewalks or played along the gutters and curbs. Whether among the standing or sitting adults, or the highly active children, the mood was proprietary and familiar. Interior domestic scenes had emptied into a common public arena and a more open space. We viewers are immersed in a spectacle that lacks a proscenium, as if the actors had left the charged cubicle of the stage to join us in the orchestra. Or rather, the difference between audience and actors was confused, and their dramatic parts made up on the spot. In the heady, gabby profusion that resulted, Levitt homed in, plain style, on moments of spontaneous bonding.

*A Way of Seeing* shows people's recurrent need to touch each other, to pair, as it might be, or to act together in groups. It's a reasonable guess that the subjects knew each other well or were related, and though this kind of sociability doesn't accord with the myth of New York as a throng of strangers (an idea, really, of the fifties), it conforms, even now, to the experience of its ethnic neighborhoods. Forty or more years after

Hine showed them arriving, the European or Latin-American immigrants (and the southern blacks on a different schedule), had settled in, acculturated to a hugger-mugger existence. This comment about affectionate tribes in seedy circumstances is quite obvious, but should remind us that *A Way of Seeing,* however lyrical, is also an inherently regional study, for it points to and draws visual interest from the physical demonstrativeness of the New Yorkers, whose largely Catholic and Jewish culture stood out in maximum contrast to the Protestant hinterland.

It was during this same period, the 1940s, that Weegee, too, took many of the pictures that were later to be gathered in *The Naked City,* a book that sensationalized body contact as a New York specialty. Highlighting hysteria and violence, Weegee carefully described the place as one live-long disaster area, and it was this alarming, yellow press flim-flam that fed so much of the suspicion and enmity toward New York in the popular culture of the time. Compared to such reportage, Helen Levitt saw New Yorkers not in collision, but as having reached out towards each other—effusively, tenderly, or often in sadness. And there were no anecdotes or myths in this evocation, only a way of seeing.

These inhabitants of the tenements grasp, hold, grip, embrace and in many ways, support, bridge or connect themselves with the things and people around them. The searching activity of the hand and the arm is emphatic in these photographs, as if to affirm, beyond any doubt, the existence of nearby presences in the shabby world of Spanish Harlem, the Lower East Side and what we would now call the East Village. To a photographer, the theme of touching can have a further, critical importance. It intimates the *continuum* of a lived, sentient appetite and response within the necessarily immobile scene. More than that, touching, in the way at least that Helen Levitt's New Yorkers do it, is in collusion with something behind the surface; it's an external gesture that attaches human value to an interior life, or it's the most direct way we're led to infer such attachment.

Cartier-Bresson, whose work Helen Levitt knew in the 1930s, and whom she acknowledges as a prime influence, was a virtuoso in "arranging" graceful visual tangents. No sooner do we comprehend the flow of his configuration than it is seen to unfold through impingements—of shadows, feet, calligraphy, puddles, fingers—that judiciously appear to

Photograph by Helen Levitt. *New York, c. 1942.* Courtesy Helen Levitt.

have just left off or are about to kiss each other. In short, it's the potential energy of the overall field that kindled him, and which he realized through a sequence of chance, kinetic attractions, suspended in time and space. Having digested that lesson, a young American woman, out to explore her New York precincts with a camera, learned that she had a different temper. For her, touch was not an illusion suggested by agile placement of the framing eye, but a real-life event. It was also definitely felt as a compressive, enfolding event, episodic, self-concerned and indifferent to the picture field.

Too frequent in their appearance to be a trace of passing, unconcerned observation, Helen Levitt's touching figures are persistently estranged in their environment. By *estranged* I do not presume anything about the figures' consciousness, but refer to our own. For we see, as they probably do not, that they're cut off in that space, that it offers a kind of resistance and has to be overcome. Kids can crawl and shinny up to the lintel above their doorways, or the trunk of the only tree in the book (and a blasted one, at that), to fight it out, let's say, with their licorice pistols and wooden swords. Whether they're little Tarzans in the jungle or junior Legionnaires in the desert, the frame nicely contrasts their charade of high adventure with the humdrum reality of the street.

When there's any openness in that space, or any failure of human approach on the part of its actors, or a derelict figure crops up, the effect is especially eloquent and painful. Instead of the buzz that one imagines elsewhere in her work, the effect here is of silence, or retreat to which the city offers no answer. Some of these loners fall back on their imagination. The kids twirl white streamers or waft bubbles in front of these inhospitable, dark stones. The fragile, brief possessiveness of their games and their idle hours is expended against a hard and unresponsive background.

So, the interplay between foreground and rear, or density and vacancy, is not so much an arabesque as a carrier of an empathic charge. The inhabited street is the site of an on-going theatrical struggle, sometimes momentarily won by the zestful figures and sometimes lost by them to the inanimate slum setting. It makes a difference to see how people are able to invent, or are frustrated in creating their *own* space. Occasionally, and very movingly, it happens that an emotional space is defined

(for us now, whatever it was then), as a reflex of some injury that comes from the outside. It is the kind of softened space one sees, in a number of images in the book, where the arms that extend from one figure to another are unmistakably sorrowful and consoling.

I wondered, when I first saw *A Way of Seeing,* how its few pictures, with their simple means, were expressed with such authority. I now think it must be because the photographs realize themselves by making a viewer ask *questions* that are peculiar to Helen Levitt's way of seeing. For example, apart from the book's middle forties chronology, there is some enigma about its *emotional* time zone. The photographs generally suggest an aura that has some intangible, but large and not benign consequence for their subjects. If that aura still holds a viewer in the waning gravitational field of the Depression, a number of Levitt's people nevertheless step out of it easily and smile. But they do not ever go so far as to trespass into the middle American area of the *Life* magazine photos of the time, with their depraved wholesomeness.

How, for instance, is one to react to the image of a hugely pregnant woman, arms folded across her bosom, who appears to look down with sniffish hauteur on a girl just then passing lightly in front of her, with two milk bottles and a grin as if she were the cat that had just swallowed the canary? The picture has Levitt's significant contrasts in depth and her sensitive account of holding hands, even if their function here, as in several of the book's photographs, is *self*-protective. I cannot associate these ironic symmetries with those apple pie comforts and anecdotal verities for which *Life* thought G.I.s were fond enough to risk themselves abroad. There is no domestic witness to the war in Levitt's work, no gold star flags, bond posters, USO clubs, etc.) But the picture of the women is also too vibrant, mischievous and bouncy to fit into the picture albums of the supposedly miserable thirties. Though rooted in their own, familiar moments, the phenomena that involved Helen Levitt did not need to be assigned any historical epoch.

"Specialized as her world is," wrote James Agee, "... Miss Levitt has worked it in such a way that it stands for much more than itself; ... a whole and round image of existence." He went on to speak of her subjects, of pastoral stock, as the embodiment of "a natural history of the soul ... fantastically misplanted in the urgent metropolis of the

body." In Agee's passion-play, only the rural folk had virtue (soul) enough to survive in the physical rottenness of the city. And Levitt's pictures had a redemptive value on two interrelated counts: first, they showed such survival in all its pity, terror and grace, and second, because the photographs were close to folk art, the product of an instinctual and pure vision.

Agee's argument, however, does not claim that Levitt's art is naive, but rather that it is occupied with innocence as subject, a very different thing. Be that as it may, he does attribute a high level of sophistication to work that could only have stemmed from urban culture. In fact, Helen Levitt met Agee in New York in 1938, at the same time that she introduced herself to his friend, Walker Evans, the most reflective and disciplined mind just then in American photography.[2] Evans was committed to projecting a study of American consciousness as embodied through its land, faces and artifacts. Though he, himself, was only partly a street photographer, he seems to have communicated almost osmotically the rigor of his ideas to Ben Shahn in the middle-thirties, and to Helen Levitt a decade later. It is instructive to compare her playgrounds and tenement scenes with their counterparts by Shahn. (Both photographers, incidentally, had used right-angle viewfinders to avoid disturbing the street life that interested them.) His earlier pictures are more unbuttoned and grimmer, but not less humane and visually rich than Levitt's.[3] As for Evans himself, Lincoln Kirstein had quite accurately written that his was a "purely protestant attitude: meager, stripped, cold and, on occasion, humorous." If we recall the gritty ebullience and pathos of Shahn, the epicurean speed of Cartier-Bresson, and what Kirstein called the "unsparing frankness" and puritannical eye of Evans, they suggest the conflicting models from which Helen Levitt, still in her early twenties, fused her *thoroughbred* way of seeing.[4]

If it had been necessary to talk around its empathies, it is certainly proper, now, to stress the detachment of Levitt's art. Her book can transfigure the ordinary circuits of human worry and pleasure because it is not engaged with them—not engaged with any moral statement before it has satisfied its zeal for poetic beauty. Or is it that the undeniable poetic beauty Levitt discovered on the streets inevitably had a moral significance—not the least of the questions asked by her work?

Levitt's photographs were not intended for any context, nor for any original use other than the one we presently see. Her images maintain their freshness as a result, and also a certain distance. At the same time, it's an extraordinarily affirmative distance. After having advanced in order to visually comprehend the people of the street, the photographer receded to let them be themselves and to speak. In other genres, content tends to determine itself through whole artifices of stagecraft that are variously photographed as a durable statement of affairs. Street photography, however, is concerned with an artless, involuntary reality of cryptic scraps and bits of visual evidence, taken for what they are. If it seems that such partial views express internal truths about the human situation, it's to the extent that the photographer, alone, reflecting upon experience, knew how to time and project, musically shape and summarize them.

The inextricable gravity, poise, mystery and charm of Helen Levitt's scenes did not pre-exist on their own. They came into being as the products of a melodic desire whose aim was to do no more than justice to the moments of its best perceptions. In their articulated setting, their vulnerable embraces, the sense they give of literal kinship, and all the delicacy with which such things resonate, these recurring moments confess their faithfulness to each other and earn for the book its miraculous unity.

NOTES

1. The initial book was to be brought out by Reynolds and Hitchcock in the forties, but was shelved when one of the partners died. Helen Levitt states that she thought little more about the project for twenty years, until it was suggested that Viking produce it. The title, from a sentence in the accompanying unpublished essay by James Agee, was proposed by Catherine Carver at Viking. All the following comments on *A Way of Seeing* in this essay are based, however, on the 1981 edition (Horizon Press), which includes twenty-four more plates than the original Viking/Museum of Modern Art book. I concentrate on this body of work because I consider it exemplary in the history of the street tradition. But I do not wish to imply that it represents anything more than a tiny fraction of what Helen Levitt created in the forties, nor am I able to discuss her productive and continuous career since then. These images, particularly her later work in color, are subjects for a much needed monograph.

2. Interestingly, Helen Levitt's first contact with Evans' work was the folio illustrating Carleton Beals' "The Crime of Cuba," an account of U.S. involvement with the Machado dictatorship of the thirties. It is suggestive, but probably only coincidental, that Evans had described a tropical locale, with its multi-racial communities, bearing up in poverty and heat rather like Levitt's New Yorkers.

3. In *The Photographic Eye of Ben Shahn,* edited by David Pratt, (Harvard University Press, 1975), compare, for instance, number 1 with Levitt's number 24, and Shahn's number 15 with numbers 58 and 62 in *A Way of Seeing*. The parallels are very intimate.

4. It is appropriate here to stress how closely mutated are the affinities among the important street photographers of New York. Helen Levitt's work crystallizes certain elements from her immediate predecessors. It then takes its place in a tradition that also includes the later images of Lou Faurer, William Klein, Roy DeCarava, Robert Frank and Bruce Davidson, who were to explore, all quite individually, yet convergingly, the poetic dissonance of the New York streets.

PUBLIC STATEMENTS / PRIVATE VIEWS:
SHIFTING THE GROUND IN THE 1950s

*William S. Johnson*

During World War II, photographically illustrated mass-circula-
tion magazines co-opted many of the concerns of the social
documentary movement of the 1930s. While these magazines
took on the mission to inform and instruct the public about the historic
events and vast social changes of the time, they also expounded the
ideologies of American democracy. After the war, they held a preeminent
position in the American popular culture. Led by *Life* and *Look,* whose
editors felt they spoke with a national voice to a national audience, and
buttressed by a host of others with only slightly less inclusive readership
such as *Fortune, Esquire, Holiday, Vogue, Harper's Bazaar* and *Show,*
these magazines provided the largest source of income for photographers
and the best public forum for their work.

But where the social documentary movement of the 1930s held to
a national purpose, the flourishing magazines of the 1940s and 1950s,
no matter how ambitious or enlightened their aims, were ultimately
limited by editorial policy, and the goal of making a profit. Photographers
working for them were expected to meet a curious and sometimes con-
flicting mixture of creative and commercial aims.

Since each magazine hoped to attract the largest possible audience,
photographic essays were expected to be understandable to every reader.
These were frequently limited to one-dimensional events, and characteri-
zations, complexity, subtlety and ambiguity were avoided at all costs.
An unwillingness to offend the many and varied special-interest groups
further limited the range of a photographer's expression. In addition,

since American journalism was dominated by a belief in "objective" or "neutral" reporting, the photographer's opportunities to express personal opinion were restricted even further.

Both W. Eugene Smith and Robert Frank began their careers within the constraints imposed by the magazines. Each, out of separate desires or needs to achieve the fullest measure of his creative abilities, rebelled against the limits imposed by the magazines, and in doing so, each helped expand the photographic essay and shift its center of gravity from the realm of popular culture into the arena of creative art.

W. Eugene Smith, raised in Kansas in the 1920s and 1930s, believed in the traditional American values he had been taught at home and in school—that America was a strong and noble country, that prejudice was bad, that war was only just as a force against evil. His early naivete was later replaced by a much more complex understanding of the world, but Smith never wavered from a core belief that all people had the right to the best possible life, and that each person should strive to improve the world. Growing up in the thirties, watching Hitler's rise to power draw the world into a chaotic war and seeing for himself the power that the magazines compelled in prewar America, Smith sincerely felt that the media was both a great and a dangerous force in the world.

During the blood and chaos of the Pacific battles Smith photographed in World War II, he questioned for the first time the generalizations that fed the mass media, and in this first step toward creative maturity he began to establish personal priorities. One of these, a determination to use photography to assist the weak and underprivileged, acknowledged the enormous power of the media to affect change. Another, his hatred of hypocrisy and bureaucracy, convinced him of the potential to abuse that power. Throughout Smith's career as a *Life* photojournalist, these two priorities were in conflict.

As a leading voice in magazine journalism in the late 1940s and 1950s, Smith's post-war essays, with individually believable pictures arranged in a more natural flow, helped to strip the earlier rhetoric from the photo essay. As he continued to expand the creative boundaries of the essay with a succession of exciting stories, his work drew an extraordinary measure of popular response; in a world wracked with violence, poverty and prejudice, Smith's photographs spoke of the pos-

sibilities of a better life. Because he believed in those ideals himself, Smith could always find images that conveyed the hopes and beliefs of the American people. For him, a moral message was a vital component of any important photograph. He achieved his best work when a person or event symbolized a larger issue, as in the case of the nurse-midwife Maude Callen, the black woman whose warm, humane character successfully opposed the prejudice that surrounded her.

By the mid-1950s Smith had evolved a personal belief system of overlapping moral and aesthetic dimensions, firmly believing that the magazines had an obligation to be truthful to the reality of the stories they presented. It was not too unusual at this time for magazines to rearrange, or even stage events to fit their editorial conception rather than present what the photographer actually found at the scene. This "truth" could be a poetic truth, rather than a simple combination of raw facts, but it had to be correct to the situation. Smith believed that his own moral imperative was to strive as hard as humanly possible to discover the correct manner to present that truth. He insisted that the photographer, as the person actually present at the event, should have an active role in the page presentation, or layout of the story. His insistence on this point was at the source of much of his continuing confusion and unhappiness within the highly compartmentalized *Life* magazine organization, and he became increasingly defensive and grimly protective of these beliefs over the years.

Gene Smith had been pampered, praised and pushed by a domineering mother, and from the age of fifteen he had steadily acquired recognition. During and immediately following World War II, after his wounding while photographing the battle for Okinawa had received national press coverage, he was considered a national hero. With the ever-increasing fame and praise he received for his *Life* essays in the 1950s, it is not surprising that this essentially modest, even shy man, would develop a sense of personal destiny.

For years Smith had worked within a private mythology of creativity that was forged out of a bed of personal pain and anguish. He felt that his reputation and his worth were based on his ongoing struggle to expand and improve the expressive possibilities and moral dimensions of the photographic essay. Many times he had proven that success came

*W. Eugene Smith working on layout for Pittsburg essay in his New York Loft,* not dated.
Courtesy the Center for Creative Photography, Tucson.

out of pushing any project beyond its "reasonable" limits, and he worked by consuming the problem, by attacking it with an energy and determination that often drove him and those around him to the edge of physical and nervous exhaustion. Unprecedented popular and critical acclaim led Smith to believe that he had accomplished his aim in the past, and that he must continue to do so. But by the mid-fifties, his frustration with the traditional elements within photojournalism had reached a peak.

Smith finally resigned from *Life* at the end of 1954. Smith had asked that his complex and subtle essay about the African town of Lambarene, and its medical leader, Albert Schweitzer, be presented either as a special issue or as a series in several consecutive issues of *Life*. To a harried editor, Smith's demands could simply have looked like an attempt to get more pages. To Smith it was a desperate effort to retain something of the nuances of his photographic essay. Almost lost in the chaos of emotions (and later, the legends) that surrounded Smith's final argument with *Life* is the fact that Smith was asserting that the photographic essay was capable of even greater dimensions than had previously been attained in the traditional *Life* format.

Leaving the highly paid and very prestigious job at *Life*, Smith attempted a career in commercial photography, perversely hoping to infuse excellence and high moral purpose into that mercantile world. To accomplish this, he felt he had to produce a work of art so definitive and so superior to anything known that his arguments could not be refuted. Although opposed to the reigning power structures, Smith chose to work within them, angry and determined to prove to the world that his point of view was right.

He quickly found his subject. Joining the Magnum agency, he took an assignment to photograph Pittsburgh for one chapter of an illustrated history of the city that was being written by Stefan Lorant. Smith swarmed into the Pittsburgh project, and during 1955 he made at least 11,000 negatives in an effort to capture every aspect and mood of the large industrial city. Smith expressed his hopes for this project in letters to friends and editors.

> *I am fighting to work a revolution in certain aspects of photo-journalism. ...*[1]

> *I build an essay photograph by photograph, idea by idea, and always having in mind the relationships which give awareness to the equilibriums of paradox within any situation. ... A comparison to the playwright probably comes closest to illustrating the way of my thinking in building a work. ... Though my approach may have little precedent ... in photographic journalism, there is a long tradition of this kind of personal essay in literature. Photographic essays must reach beyond their realizations as now achieved ... it is imperative. ...*[2]

Smith looked to traditional art forms such as literature, drama and music for both inspiration and techniques to extend the known boundaries of the photographic essay. He wanted to create an epic narrative poem along the lines of Walt Whitman's *Leaves of Grass.*

Smith and his assistants made at least seven thousand proof prints during the next year. He then began to edit this huge body down to the two thousand images that would constitute his version of the Pittsburgh essay. He turned down or lost a number of jobs during the next two years, taking brief projects only reluctantly and under extreme pressure. At times he received support from various sources, notably the Guggenheim Foundation in 1956 and 1957, but his sense of pride made him return more than he received. He sank all of his resources into materials.

Smith filled his home and later his studio with panels on which he continually rearranged hundreds of proof prints in kaleidoscopic variations of mood and texture. They constituted the most comprehensive document of a city to be assembled by a single individual, but the work was transitory, existing only from moment to moment on those panels. The "equilibriums of paradox" continued to defeat him. To Smith, it seemed impossible to freeze that nuance of mood in anything less than hundreds of images; impossible to winnow it down to a magazine-length, or even book-length essay. He tried to work with the staff of *Look* to produce a feature story, and then he even tried with *Life,* but each attempt ended in failure and additional frustration.

The project continued amid a storm of conflicting emotions, many of them self-destructive. The death of Smith's mother in 1955, shortly

after he left *Life,* must have released a complicated mixture of loss, relief and guilt in him. In addition, his marriage had been in trouble for years, and he now poured enormous emotional energy into alternately trying to make it work and trying to escape from it. By the late 1950s, Smith had exhausted all his money and credit, and most of his energy, working on the Pittsburgh project. His Croton, New York, house was being sold and his family was breaking up; he spent more and more time in his New York City loft studio, gradually acknowledging the failure of his marriage. Distracted by other projects, and realizing that he would never be able to publish the essay in a major magazine as he wished, Smith finally agreed to publish it in the *Popular Photography Annual.*

Again he sifted through hundreds of possibilities as he arranged the 4 by 5-inch proof prints on the panels; again he sorted through the potential layouts that had been put together by himself and the staffs of *Life* and *Look,* trying to cut it down to one final, superb statement. "The Labyrinthian Walk," as Smith called it, was published in 1958. It consisted of 88 black and white photographs arranged on 34 pages.

Smith, however, considered the essay a failure at publication. He had been confounded by the difficulties of moving from a larger to a smaller page format, of shifting the paper grade and printing quality from the multimillion dollar operation of *Life* down to what *Popular Photography* could afford. Already in a posture of ironic despair, and sensing the continual loss of possibilities as the essay narrowed down, Smith had hoped to transform the essay through the power of his writing. He wrote and rewrote, pushing further into a more extreme and extortive prose in an attempt to infuse a sense of exhaltation into the work.

When he sent in the final text, he apologized to *Popular Photography* editor, Bruce Downes.

> *The Text: a last numb little effort, a picking at threads. ...*
> *Today, I am at face ... with the failure of my effort ... these last*
> *desperate efforts have produced a wry and tragicomic satire of my*
> *total intent ... it had defeated—the effort at revolution. ...*[3]

On Smith's terms, the project was a failure because it did not conclusively prove that the photographic essay should move into the epic

mode that he had envisioned. Although it was discussed, wondered about and even marvelled over, "Pittsburgh" did not overthrow the established photojournalistic community. The essay became a curiosity, rather than a landmark of impeccable authority.

Robert Frank grew up in a well-to-do, bourgeois Jewish household in Zurich, Switzerland, during the 1920s and 1930s, his family delicately balanced in a tiny pool of calm amid the terrible destruction all round them. "Every day on the radio," Frank said, "you heard Hitler threatening, cursing Jews ... the fear I saw in my parents ... if Hitler invaded Switzerland that would be the end."⁵ The family coped with this pressure by striving for absolute colorlessness, by being "correct" in every phase of their lives. The young Frank was also pressured to behave and to be careful in everything he said and did.

Frank reached adulthood with a tremendous fund of anger at authoritarianism of any form, a distrust for organizations and a quiet, impeccable resistance to pressure. But he also had a firm belief in the human spirit, based in the harsh, stripped affirmations of post-war French existentialism. Andre Malraux, Jean Paul Sartre and Albert Camus, whom he read and was influenced by, presented a world of iron necessity, where the drama of men's lives was connected to social and political movements; where a man must choose to act to create a world of human values in the midst of vast, impersonal forces.

Frank took up photography at the age of eighteen to get out of the orbit prescribed for him by his family. By age twenty-three, when he left for New York, he had gathered six years experience as a photographic assistant. Moving to New York in 1947 to pursue a career as a commercial photographer, he very quickly decided to earn his living as a freelance. He rapidly developed a habit of independence, as well as a unique, personal photographic style.

In 1948, after working briefly for Alexey Brodovitch at *Harper's Bazaar,* Frank left for a self-financed, three-month trip to Peru and Bolivia.

*I went to Peru to satisfy my own nature, to be free to work for myself. ... I switched to the 35mm camera in Peru. I was making*

*a kind of diary, I was very free with the camera. I didn't think of*
*what would be the correct thing to do. I did what I felt good doing.*

During the next few years, Frank moved back and forth between
New York and Europe, photographing in Paris, Valencia and London.
By 1950, he had mastered the art of capturing the character of a place
and the mood of a situation in one swift, unobtrusive glance. At first, it
seemed that Frank would move easily into the kind of photojournalism
practiced after the war. His work, described at the time as "poetic"
and "lyric," received critical recognition both as personally distinctive
and as a meaningful part of the direction that photography seemed to be
following. But Frank simply would not, or could not, tailor his style
to fit comfortably within the needs of the editors of the mass-
circulation magazines.

In the early fifties, Frank lived in the Village, in the midst of the
group of painters that came to be called "The New York School." His
attraction to these artists came from their spiritual resistance against the
banality and increasing conformity of American cold war culture.

*You live on 9th and 3rd and around you are painters and*
*galleries and you watch what goes on. You're not a painter but it*
*does something to you to be around them and watch how they*
*believe in what they do. It reinforced my belief that you could really*
*follow your intuition.*

Frank's intuition was drawing him away from the accepted ideals and
the sentimentality that dominated the media.

*I went away from my early lyrical images (i.e., of Paris) because*
*it wasn't as good as that—it was a myth that the sky was blue and*
*that all photographs were beautiful.*

Frank continued to make a living producing commercial work for
*Junior Bazaar, McCall's* and other magazines, and his personal work
appeared in specialist periodicals. He never really advanced to the fore-
front of the profession or to the awareness of a wide public audience,

even though both areas of Frank's work were appreciated by a knowledgeable minority. Attracted to his photographs, editors would give Frank assignments, but decide afterwards that his pictures didn't "fit" their magazine's stance. Frank was chagrined and disturbed by these inconsistencies, and grew wary and then disdainful of a system that he felt was often hypocritical and opportunistic.

> *I developed a tremendous contempt of* Life *magazine. ... They wouldn't let me in ... and I hated those goddamned stories with a beginning and a middle and an end. Obviously I had to make an effort to produce something that could stand up to any of those stories but not be like it.*

A Guggenheim Fellowship gave Frank the opportunity to try.

> *[In the early 1950s] I always tried to come up with one picture that really said it all, that was a masterpiece. But I had used up the single, beautiful image. By the time I applied for a Guggenheim, I decided that that wasn't it either: it had to last longer, be a more sustained form of visual [expression]. ... There needed to be more pictures that would sustain an idea or a vision or something.*

Frank's fellowship application stated his aim: "To produce an authentic contemporary document, the visual impact should be such as will nullify explanation."⁵ Frank made, in a series of trips across the country during most of 1955 and part of 1956, approximately 1500 photographs. As he returned from each trip he made contact prints, searched for themes and patterns that surfaced in the images and, finally, printed up several hundred of the most significant photographs. As he began to order these into broad groupings and winnow them down to a final form, he decided that a book would be the best manner of presentation. He adopted a simple pattern, with one picture per page and the whole organized into four large groups, each beginning with an image of the American flag. In 1957 Frank completed the macquette for *The Americans*.

The *Americans* was rejected in America. *Life* magazine put together a layout but decided not to publish it. When no other publisher in this

country would accept the book, Frank took it to his friend Robert Delpire in Paris, who was able to publish it there in 1958. The avant-garde New York publisher, Grove Press, then published it in 1959.

Frank's quiet affirmation in *The Americans,* and the importance of the work as a personal view, was either misunderstood or overlooked by established critics, whose initial response to the book was shock and dismay. Virtually all of the "official" discussion of the book in the photographic polls was negative. In fact, *The Americans* is a profound and compassionate portrayal of individuals living blighted and truncated lives in an industrial technocracy. Frank was able to show a damaged ecology, inane and divisive institutions, poverty, racism and a discordant and alienated society, yet he also found images that dealt with the human verities of resistance, endurance and faith. Throughout *The Americans,* Frank expressed a lyrical regard for the possibilities of the human spirit and a tightly controlled rage at the multitude of forces that prevented the full potential of that spirit from being realized. This second, calmer reading of *The Americans* has emerged only gradually out of the earlier, more distressed responses to Frank's perceptive and ironic vision.

Robert Frank and W. Eugene Smith were on nearly parallel courses during the second half of the 1950s. Both had come to reject the dominant ideologies espoused by the hierarchies of the photographic profession. Both felt the necessity to counter these powers, and both felt the only way to do so would be to produce some work of singular merit. They knew and respected each other, and to some measure were aware of what the other was trying to achieve.

Within their shared concerns, however, their course diverged. Gene Smith, because of his character and the accidents of his life, came to believe that he had both the mission and the burden to wrench the entire field of photojournalism to a different direction single-handedly. Embedded in a mood of self-destruction in the late 1950s, he organized projects so out-sized in their conception and execution, so unyieldingly demanding against the established forms of the photo essay, that they seldom reached the public for which they were created. Smith did not truly reach an international audience again until the 1970s, when he produced his book-length essay on mercury pollution in Minamata, Japan. In spite of his feeling that the Pittsburgh essay was a failure, however, he had suc-

ceeded in welding together a sense of personal responsibility, his superb photographic skills and an ambitious project into an effort that extended his reputation with the rising generation of young photographers.

Robert Frank's aims were more modest, and more achievable.

> *I heard Smith talk about it (the Pittsburgh project) sometimes when I met him. It seemed very big to me. I think small. I know one should think big, but when you think big you can trip.*

Frank doesn't in fact, "think small," but he has never confused volume with value, or size with importance. His project, like his photography, was focused on the singular, concerted effort.

By the 1960s, younger photographers were suspicious of the concept of one homogeneous American society that was still advocated by the national magazines. Along with this loss of belief in a national voice, came a lessening of their faith that the mass media could affect sweeping social and political change. Attracted to the variety and individuality of subcultures within the larger polity, "social" photographers began to document these groups with a depth and specificity unheard of in the 1940s and 1950s. They insisted on longer-term commitments, and so their work became denser, and more personal. A source of these new values and different meanings is clear in the actions and works of Robert Frank and W. Eugene Smith, who learned to look on their efforts not as failed photojournalism, but as powerful acts of personal expression.

NOTES

1. Letter to *U.S. Camera* editor/publisher Tom Maloney, October 13, 1955. All quotations from Smith letters are drawn from the files of the W. Eugene Smith Archive, Center for Creative Photography, University of Arizona, Tucson.
2. Letter to *Look* editor William B. Arthur, March 3, 1958.
3. Letter to *Popular Photography* editor Bruce Downes, June 22, 1958.
4. Unless otherwise credited, all quotations from Robert Frank are drawn from a series of conversations with him at his New York City apartment by Susan E. Cohen and the author during the summer and early fall of 1983.
5. Robert Frank, "A Statement" *U.S. Camera 1958* (1957), *115*.

# THE PHOTOGRAPHS OF LARRY BURROWS:
## HUMAN QUALITIES IN A DOCUMENT

*Mark Johnstone*

L arry Burrows was not comfortable with the label war corres-
pondent, or photojournalist, or any title that suggested he was
only one particular kind of photographer. There are few of us
who are not familiar with Burrows' photographs, which, in a manner
both eloquent and brutally direct, so intensely described the war in
Vietnam on the pages of *Life* magazine throughout the 1960s. But in
addition to returning time and again over a nine-year period to cover the
war, Burrows also produced dozens of other equally potent essays on
subjects as varied as the Taj Mahal, New Guinea birds of paradise and
the architecture of Angkor Wat.

It was neither accident nor simply a well-intentioned gesture that
the posthumously published book of Burrows' work was titled *The
Compassionate Photographer*.[1] The evidence and reason for such a
description lies in his work, not only in the photographs of Vietnam,
or the many other tragedies and horrors that he covered throughout
the world, but in the way he photographically covered and conveyed
an assignment.

Our ability to appreciate how a photographer reveals a subject has
grown immeasurably over the past twenty years, and as we have learned
something about photographs we have also learned to judge the values
of their makers. Burrows was given many routine assignments that
covered a variety of subjects, but he continually gravitated towards
depicting people. A quality present even in this early work is a sensitivity
to the existence of the person pictured. This characteristic style persisted

even as the circumstances under which he made his photographs became more extreme and dangerous.

A native of Britain, Burrows' photographic career had an inauspicious beginning. He served in the military in the Yorkshire coal mines in 1943 and 1944, and then worked as a darkroom technician at various agencies, finally ending up in the London Bureau of *Life* magazine. In the 1950s he free-lanced, following the political leaders and personalities of the London scene. It was during this period that he first worked as a photographer for *Life,* for which he photographed master paintings, old buildings and objects of art throughout Europe for a variety of stories. It was highly technical work, and not particularly creative; but it instilled in him a self-discipline towards his subject and an appreciation of color that he would later bring to bear on his mature work in Vietnam.

When he joined the staff of *Life* in 1961, Burrows had already covered a number of riots, wars and revolutions in diverse places around the world. These ranged from events in colonialized areas that were forcing the issue of their own independence (the Congo uprising at Leopoldville), to internal conflicts (the Mosul rising in Iraq; the war in Cyprus), to confrontations between nations (India and China; the Anglo-Egyptian dispute in the Suez Canal). Based in Hong Kong, his first *Life* assignment in the Far East was a story on Dr. Gordon Seagrave, a surgeon who had worked in a remote region of Burma on the border of China for over forty years. It was during this period that Burrows "found" Vietnam.

When he first visited Vietnam in 1962, the war was largely a struggle between the Vietnamese, but the nature of the conflict changed radically as the United States escalated its involvement. Although evidence of his concern rarely appeared in his photographs printed in *Life,* Burrows was highly sensitive to the traditions and culture of the country. To him it was a land of ancient beliefs and formalities involved in a modern war. He initially felt that the American involvement was justified and right; but, as the war dragged on without resolution, he grew disillusioned, bothered by the intervention of a larger country in the interests of a smaller one. In his photographs, the war became something much different than an attempt to check the growth of communism in Southeast

Asia. He depicted instead the individual struggles within the country by those who tried to make life more rational and humane.

If one were to enumerate the photographers who worked in Vietnam during U.S. involvement there, the list would be quite long. Almost all of the international correspondents and photojournalists working during the 1960s spent some time in Vietnam, many only two weeks. The brevity of this time period should not appear strange, however; for this is the way many world events are covered by the weekly press. The names and work of many of these Vietnam-era photographers will be familiar to followers of photography, photojournalism or current events: Phillip Jones-Griffiths, Mark Godfrey, Eddie Adams, Horst Faas, Nick Ut, Henri Huet, Donald McCullin, David Douglas Duncan, Kyoichi Sawada —the list could go on.[2] Burrows, however, was one of the few, if not the only one, who covered the war from the United States' initial involvement until most of the American troops had been withdrawn. Some of his photographs were made as routine assignment work, but most were self-initiated and came out of the freedom that *Life* allowed him.

The photographs that came out of Vietnam are important for more reasons than simply providing us with a history of the events there. This was the first large war that was depicted in highly individual ways by photographers who wished to express their experience of the land, the people and the war, rather than showing only the circumstances, events and victims of it. Grisly details were put into print time after time in images that were neither dignified nor well composed. It was a war that was presented by the media through widespread investigative reporting, one that was also filled with what were later termed "media events." For the first time the public was made a privileged viewer of the violent interrelationships of politics and power. The public experience of those pictures was shaped by the context within which they existed, the articles and captions of the press.

Vietnam was also the first war reported widely on television, and while the idea has been repeated frequently, it must be noted here that there was something insidious in seeing the conflict on the news every night in the privacy of one's living room. Separated from their numbing, even shocking presentation in the original form, many of these images, both still and video, have become emblematic of the Vietnam experience.

Photograph by Larry Burrows. *Jim Farley aids wounded in his chopper, Da Nang, 1965.* Courtesy the Larry Burrows estate and *Life Magazine.*

Looking at pictures of the war in the 1980s, one may be blinded by the proximity of the event in a way that makes it difficult to judge objectively and realistically what the photographs convey, and how well they convey it. Yet that is what must be done in order to assess the relative worth of Burrows' photographic career.

Proper preparation and planning were an important part of Burrows' regular work routine, and he was meticulous in studying a situation or scene. Apocryphal (and true) stories exist about the amount of equipment that he would haul along on assignment in anticipation of every photographic need. His gear filled twenty-six cases, and transporting it sometimes required a second car or jeep. He custom designed his own bush jacket with extra pockets. When he went into a combat situation and wanted to be able to move freely, he carried only four cameras, filled the pockets of his jacket with supplies and stuffed extra rolls of film into his socks. At the end of a day's shooting, wherever he was and under whatever circumstances, he made notes about every exposure that he had taken; he rarely forgot the circumstances of a single image. It was his job as a photojournalist to find those physical details and actions that revealed the inner meaning of events, and his strategies contributed not only to the dramatic pictures he made, but also to his survival. In the same way, Burrows' photographs display an understanding of the power of the events, and of the separateness of his audience, which experienced them on the pages of a magazine.

The shocking and horrific qualities of Burrows' work are visible in the first of his Vietnam photographs published by *Life* (January 25, 1963). This caption described one of the images: "South Vietnamese soldiers and U.S. advisors view dead and captured enemy soldiers on shore of the Mekong River." The picture almost appears to be a casual glance over the scene, and the circumstances depicted reinforce that feeling. The scattered, barefoot bodies of the dead soldiers, arms askew and outstretched, clothed in black peasant pajamas, lie strewn in the center of the image. Their weapons have been piled on display in an equally haphazard manner not far away. A line of several prisoners, bound and sitting in the mud, can be seen at the edge of the picture. What gives the image its eerie feeling is both its muted color—predominately shades of green and brown that blend into one another—and the

disdain of those in control of the situation. From the smiling American advisors in the background to the soldier in the foreground who stares into the distance, the triumphant figures dominate the fallen dead and crouching prisoners of war. No one in this image visually or physically challenges the photographer; the scene is presented as a tableau not unlike the dioramas in a natural history museum, packed with detail yet incidental as an event. One might wish to explain the how and why of Burrows' organization of line and space and color, to reveal through the composition the power of his vision, yet to do so ignores the real meaning of the picture—that the foreground soldier is no different from the dead men except for his American-style military garb, that the Americans in the background seem to be content with the outcome, and that nothing has been clearly achieved.

The way that Burrows recorded the war was simply to follow the course that it took, and he flew on hundreds of missions during the nine years that he spent in Vietnam. As the U.S. Government committed more men and equipment to South Vietnam, his stories came to reveal the technological superiority held by them. Burrows shot over seventy rolls of film for the essay "One Ride with Yankee Papa 13" (April 16, 1965), a story on Marine helicopters that was originally intended to show everything that the soldiers were involved in, both on and off the job. He flew scores of missions with different crews, but concentrated on one —"Yankee Papa 13"—which he selected because of the unlucky connotations of its number. When it encountered extremely heavy fire during a flight on which he was present, with one crew member killed and another severely wounded, he decided to present the story from the point of view of that single flight. The fourteen-page essay chronicled the mission from the squadron briefing on the airfield runway, through the events of the disastrous flight, to the resulting emotional breakdown of the crew chief after it was all over. It was a story that showed Americans not only as vulnerable despite their technological superiority, but killed by an unseen enemy. It also marked the beginning of what became the disillusionment of the American soldier, one centered around the fact that there was no progress, no pattern, no victory to be easily grasped; and, as a consequence, no real understanding of an individual's role in the war.

As a logical counterpart sixteen months later, a second essay, "The Air War" (September 9, 1966), clearly demonstrated how impersonal the war was to become from the point of view of some American soldiers. The pictures are spectacular, cleanly designed with beautiful colors, yet they are also grim and dispassionate in meaning. Most of the human qualities usually present in Burrow's work are absent from these images, but it is precisely their rigidly controlled design that endows them with a fidelity that begs us to examine or judge the emotion and meaning underlying the event of the photograph. They do not show dramatic moments of human interaction (or action), but a series of machine movements that wreak havoc on the Vietnamese countryside. Like the stills of a movie, we know that these events exist within the flow of time, and that there is something more outside the pictures; thus we realize that the machines do not move by themselves, but are controlled and directed by men. We know that the result is great destruction on the ground, but we never see it. We also know that not only are other men, but women, children and animals as well, are blindly destroyed and maimed.

The ambiguity in Burrows' work is not accidental, but was largely created. He positioned himself for specific angles, even in combat. He would shoot the kinds of things that had been seen before in all modern wars—the stressed individual, the haggard soldier, the action of battle— but he would also follow one man to see what *he* saw. He tried not to show the faces of the American dead, but obscured them, making their death a more general symbol. In one sense, Burrows' position was a political one that chose a sympathy with the American involvement and mythologized death. Seen another way, it was his method of getting as close to the viewer as possible. He did not turn away from the suffering; neither did he extol the grotesque. If a wounded or maimed individual was photographed, it was to arouse a sense of compassion in the viewer. His purpose was to show an American audience what the war was all about, to have them look at what he was showing them. The viewer was not to get angry with just a single man, but with all men—or mankind— and their catastrophic creations of war and suffering.

This larger sense of the war's effect on human beings and human lives is what drove Burrows to produce his later essays—one on Nguyen

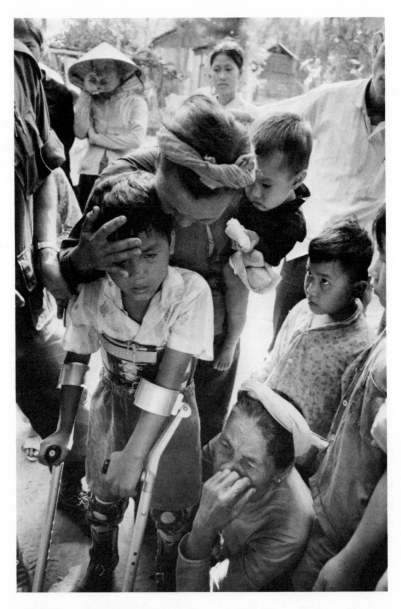

Photograph by Larry Burrows. *Crippled Vietnamese Boy, 1971.* Courtesy the Larry Burrows estate and *Life Magazine.*

Thi Tron, a twelve-year-old girl who had lost a leg (November 8, 1968); another on Nguyen Lau, a ten-year-old boy paralyzed from the waist down (January 29, 1971). Burrows believed in the Vietnamese, and recognized what they needed to achieve to survive as a nation. Simultaneously, he came to believe that the American efforts, however admirable at the onset, were not helping the Vietnamese to reach those goals. He attempted to show photographically not only what effect the war had on the Vietnamese people, but who they were and what comprised their lives. These photographs from projects not published in *Life* formed a systematic attempt to portray the country, from the individual farmer at work to the housing condition of civilians in the cities, to the training programs designed to make improvements in all areas of their life.

Considered in the broad spectrum of world events, Burrows' photographs belong generically to the standard journalism that appears weekly in *Time* or *Newsweek,* or on the nightly television newscast. The distinction that must be made between the news magazine and *Life* is the degree of interpretation that existed in the different journals. *Time* and *Newsweek* generally publish any picture, whether "good" or "bad," in order to cover the news that needs to be reported; the photographer functions as a recorder, not an interpreter. Comparatively, the photographer at *Life* was allowed to extend a point of view through a series of pictures, not only because they imparted additional information, but because they were also "good" photographs. In this way, Burrows' work can be placed in the crusading journalistic tradition of photographers such as W. Eugene Smith and Margaret Bourke-White. Like them, Burrows turned his camera to the individual, making his or her trials and struggles his own. As their pictures were remarkable in their time and age, Burrows' were remarkable in his. They produced the graphic physical evidence of war and began to describe for the average American soldier the other experiences that were Vietnam—the people, the day-to-day drudgery and attempts to stay alive.

The bulk of Burrows' work, executed in color and often highly designed, was an anomaly in the era when it was done, but seems pioneering by today's standards. Burrows chose to use color not because it created an aura of modernism in the work, but because it could be both beautiful and horrific in ways not possible through black and white.

In retrospect, it was often the use of black and white that gave a subject an aesthetic context, for it stripped the image of those particular qualities that made it part of everyday life. A photograph in black and white could only be brutal, while in color it might be simultaneously ordinary, surreal and gruesome. Indo-China was—and still is—an exotic part of the world with which most Americans are unfamiliar. It was through color that Burrows could convey the sense of romance and primitive mystery that he felt in the land and its people.

Larry Burrows tried to convey through his photographs what had never been done on such a wide scale over such an extended period of time. He tried to awaken our conscience by arousing, even disturbing, our aesthetic sensibilities. A photograph has value as a document if it tells us something of the place or person or event that is pictured. Its importance and significance are further enhanced if it reveals something about what is pictured, and something more about the photographer. At times it is not particularly popular to speak of values, but the best photographs always have values we can admire from which we can learn something indescribable that may shape our lives. There is always something to be learned about care and compassion.

NOTES

1. Burrows was in Calcutta photographing the political corruption and the deterioration of society in the aftermath of a vicious and devastating cyclone when the invasion of Laos began in early 1971. He quickly returned to Vietnam, and on February 10, a few days after his arrival, he was riding in a helicopter in Laos, near the front lines, that was piloted by an inexperienced Vietnamese. The pilot strayed too close to enemy fire and the helicopter was shot down; there were no survivors. The only complete reference of Burrows' work is *Larry Burrows: Compassionate Photographer* (New York: Time, Inc., 1971). I would like to thank Russell Burrows, Larry's son, for relating many anecdotes about his father, for answering endless questions and for making unpublished notes and contact sheets available.

2. The great majority of the photographers who worked in Vietnam during the war spent only a few weeks there on specific assignments. Horst Faas, like Burrows, stayed in Vietnam for an extended period, and left shortly after Burrows' death, feeling that the odds for his own survival were diminishing. Faas worked primarily for the wire services and didn't have the freedom to do essays, but rather was often called upon to perform perfunctory assignments such as covering press conferences.

# PROPAGANDA AND PERSUASION

*Estelle Jussim*

*In reality, to distinguish exactly between pro-
paganda and information is impossible.*

JACQUES ELLUL

*I*t is curious that the literature of photography contains far more
about the chronological history of "documentary" than about how
documentary photography succeeds in persuading, how the photo-
graphs manage to influence public opinion. Beaumont Newhall has
observed that a photographer engaged in the documentary strategy
"seeks to do more than convey information. ... His aim is to persuade
and convince."[1] Yet, outside the labyrinths of semiotics, we find few
writers who pursue the processes by which photographs can persuade,
if indeed they do.

Such processes of persuasion clearly involve not only the psychology
of individuals and the social psychology of groups, but the mass psychol-
ogy of entire cultures and societies. It is the study of the *audience* and
the context of its response that has been most neglected. Even in his
exemplary introduction to the logic of "documentary," *Documentary
Expression and Thirties America,* William Stott seems more concerned
with establishing the definitions of certain sub-genres than in investigat-
ing the peculiar workings of public opinion, although he makes it
adequately clear that "Almost all social utterances involve propaganda

because almost all seek to influence opinion."[2] He would agree absolutely
with Beaumont Newhall that it is not information that the documentary
photograph supplies, but an inescapably biased form of communication
that is equally present in all forms of exposition. In their simplest terms,
Stott's hypotheses rest upon the recognition that the so-called informa-
tion in documentary photography is always biased.

Communication is intended to alter behavior, even if only the be-
havior of believing. "Information" is never neutral, since it is always
received and interpreted by individuals according to their idiosyncratic
beliefs, tempered by the massive conditioning which their socio-cultural
environment provides. We have only to recollect that when Americans
went to India to bring enlightened birth control methods to an overpopu-
lated, hungry society, they were greeted as genocidal fanatics intent on
destroying the children needed to support their aging parents. Informa-
tion that we believed would alleviate the desperation of poverty was
interpreted as depriving families of their fundamental economic structure,
not only endangering the safety and authority of elders, but subverting
the foundation of Indian society.

So much for the presumed neutrality of information. It is clear that,
rather than through the logic of the message, individuals receive and
process information through the screen of their personal stakes in a given
behavior, or through the cracked mirror of prejudice, and always by
emotional responses that require the most subtle manipulation to achieve
a desired effect.

The task of photography in persuasion would seem, then, to be
extremely difficult, if not impossible. Can the single still photograph
persuade? If so, how, and if not, why not? William Stott claims that "the
heart of documentary is not form or style or medium, but always con-
tent."[3] He offers specific parameters of that content:

> *Documentary treats the actual unimagined [i.e., non-fictive]
> experiences of individuals belonging to a group generally of low
> economic and social standing in the society (lower than the audience
> for whom the report is made) and treats this experience in such a
> way as to render it vivid, "human" and—most often—poignant to
> the audience.*[4]

Photograph by Russell Lee. *Instruction at Home, Transylvania, Louisiana, 1939.* Courtesy
The Library of Congress, Washington, D. C.

A photograph that seems to satisfy Stott's description is Russell Lee's *Instruction at Home; Transylvania, Louisiana, (1939)*. A young black woman, handkerchief on her head, wearing an ill-fitting, worn sweater over a flowered print dress, and dusty shoes, points with a stick toward a home-made "blackboard." This piece of linoleum supports chalk writing: "The rain are fallin," then a row of numbers and the alphabet. Seated on two hard-backed chairs are two attentive young black boys who are learning how to read and count. The environment, a newspaper-lined shack, includes a calendar, various domestic appliances such as an oil lamp, a water pitcher, a chest of drawers, matches, spools of sewing thread and irons; the fireplace has been stuffed with rags around its perimeter to keep out drafts, and the floor boards are clean. Lee's photograph is vivid, "human" and poignant—but to whom?

From a liberal viewer, the following response might be elicited. "Blacks in the South were not allowed to learn how to read or write and their education continued to be rudimentary long after the Emancipation Proclamation; rural blacks lived in demeaning conditions of desperate poverty, but managed courageously to teach each other the most important skills for an increasingly technological society; blacks who could not read or write were easily denied the vote, and so this photograph by Russell Lee has captured the essence of the black condition before the Civil Rights struggle of the sixties." That response is predicated, of course, on the liberal viewer knowing something of the extensive history of black deprivation in the deep South. A liberal who also happened to know something about what is called "Black English" would see the phrase "The rain are fallin" and recall that African languages occasionally attach plural verb forms to singular nouns.

Now the same photograph in the hands of a viewer from the Far Right might elicit an entirely different response. "Blacks are a threat to white America; they are disgusting; they are stupid—look at that sentence 'The rain are fallin'—any white child of six knows better than that; teach them to read and write and they'll only vote in their own kind, like the black mayor of Chicago; then they will want our jobs; blacks must be kept out of white schools because they will lower the general educational level; they're probably on food stamps or welfare and they are just a burden to whites."

One photograph verifies two entirely opposing ideologies. That would seem to be inevitable, since what communications theorists call "cognitive dissonance" is always operative. Cognitive dissonance is the process by which individuals reject information that does not support attitudes already held or decisions already made. A belief system or ideology represents a series of decisions to be made: namely, to believe or not to believe what the communications environment provides. It has been discovered that people tend to read only what will verify or support their opinions, since new thinking requires change and change is always painful or threatening.

*Instruction at Home* was produced by Russell Lee as part of his ongoing work for the Farm Security Administration photography division under Roy Stryker, who considered Lee to be one of the best documentarians in that program. But showing the Lee photograph to someone who held views antithetical to the progress of poor blacks in American would do little to change opinion. As Einstein observed, "Theory precedes seeing." Theory is not altered by "seeing" if the seeing is skewed by strongly held opinions tied to emotional responses. It is extremely doubtful that we would call Lee's documentary photography a document capable of persuasion *by itself.*

Stott's paragraph, quoted above, refers to documentary as treating individuals of low economic and social standing relative to the audiences for whom the report, the photograph, was produced. Does this rule out Weegee's sardonic "documents" of the very rich, say, entering an opera house bedecked in diamonds and furs? Does the presence of a bedraggled onlooker in that famous picture automatically make the group suitable for the documentary category? If there is in documentary only the presentation of the lower socio-economic classes, what is expected of the viewer? Is it only, as Stott's paragraph suggests, that the viewer should have a "vivid, 'human' and poignant" experience? Is no action expected to follow? Or is this supportive, verifying experience simply bolstering the liberal point of view with no specific action to be taken? Is it only the wealthier individual at the top of the social status index who can look at Lee's photograph with superior knowledge and sympathy because—presumably—it is only the wealthy who are better educated and are in the power position to right the wrongs depicted? If so, then action

is definitely anticipated, and it is for action on the political and economic level that the photograph was, in fact, expected to fulfill its function, whatever its actual effect or result.

According to Jacques Ellul, author of a provocative work on propaganda, the idea of stimulating action as a result of persuasion is a relatively new one. The Victorians generally conceived of persuasion as having the aim of manipulating the change of ideas and opinions, "whereas the aim of modern propaganda is no longer to modify ideas, but to provoke action. It [the aim] is no longer adherence to a doctrine, but to make the individual cling irrationally to a process of action."⁵

The popular notion of this process of action can be found in some of the legends of landscape photography, although landscape photographs are probably not thought to be propagandistic. There is the story to the effect that Ansel Adams' photographs for his book *Sierra Nevada: The John Muir Trail* so impressed the then Secretary of the Interior, Harold Ickes, that he promptly brought the book to the attention of President Franklin Roosevelt. The result was that Congress established the half-million-acre Kings Canyon region as a national park in 1939. This story satisfies an outdated conception of how communication works—a picture presented to the right person at the right time galvanizes swift action, delivering a desired result in a simple cause-and-effect fashion.

But let us imagine showing the same Ansel Adams book to the first Secretary of the Interior under President Ronald Reagan, with the assumption that James Watt would so enthuse over the pictures that he would pressure the President to urge the Congress to legislate another national park. The idea is patently absurd. Anyone who followed the career of Mr. Watt would know that pictures of magnificent forests would trigger his thoughts of the timber industries, while photographs of glorious mountains and "empty" natural vistas would inspire greed for coal and natural gas exploration. Photographs by themselves resemble Holy Writ, which the Devil has been known to quote to his own advantage.

It has been customary to think of propagandistic landscape photographs as belonging primarily to the catastrophe genre. Dorothea Lange's often reproduced *Tractored Out* belongs to that category. As William Stott describes it, the picture (he calls it "noble") is of "an abandoned

Photograph by Marion Post Wolcott. *Harvest Scene,* not dated. Courtesy The Library of Congress, Washington, D. C.

tenant shack floating in a sea of tractor furrows that rise even to the porch."[6] To William Stott, the picture offers a completely self-contained explanation of the absence of humans and the cause of their having been evicted. Lange herself believed that her brief captions would tell the story. On the contrary, it is entirely possible to look at the picture, read its caption and nevertheless devise completely irrelevant scenarios: the owners of the property had been greedy and overplowed their land; perhaps a death in the family had occasioned their hasty removal from the farm. The established facts of the Dust Bowl era are that huge agribusinesses, taking advantage of the Depression, were buying up small farms to create uninterrupted tracts of land susceptible to being farmed by the new agricultural machines. Despite Stott's opinion of Lange's Dust Bowl pictures as being "noble," *Tractored Out* does not function as propaganda, even with its explanatory caption, without the viewer having a knowledge of the context of its imagery. Without context—the context of other photographs, the context of the economic and political realities of the time, plus *the context in verbal terms* of how the image related to those realities—there can be little chance that a single picture can convey not only its intended meaning but a persuasive message that could motivate action.

It may come as a surprise that Marion Post Wolcott's photograph of a harvest scene—a landscape cliché if ever there was one—was *intended* as propaganda. This is an example of the legerdemain that Roy Stryker performed when the second World War broke out in 1939. Forced to shift abruptly from the social reform pictures produced for the FSA to direct support for the war effort, he called on documentary photographers, who had previously been engaged in depicting the sorrows of the Depression and the exhausted land of the Dust Bowl, to produce overt propaganda proclaiming the might and abundance of the American earth. His instinct was perfectly on target, since few threats can arouse emotion faster than the implied destruction of your homeland. Using imagery associated with Thanksgiving and that season's cornucopia of good food, Wolcott's display of cornfield harvest abundance undoubtedly was intended to promote feelings of security, to remind us of the great productive capacity of the American nation and to arouse the identification with a bountiful land on which all patriotism may

depend. The documentarians (if such they could be called in their new roles) were giving the "common man" something positive in which to believe, something to love and to fight for, using the same realistic technique but an entirely new content. The new content, according to Stott's definition, would remove these wartime pictures from the realm of pure documentary and place them in the category of pure propaganda.

Since neither the Russell Lee photograph nor the Marion Post Wolcott landscape could operate effectively without prior consent to their underlying assumptions, their utility as propaganda would depend on what Tony Schwartz, a master of public opinion, calls "the responsive chord."[7] In the absence of communication that resonates with what is already in the hearts and minds of the audience, propaganda cannot arouse emotion and subsequent action. But Ellul argues that propaganda is a two-stage process, not a simple one-to-one, cause-and-effect event. Ellul suggests that *pre-propaganda* is required to mobilize psychological responses by replacing the established conditioned reflexes partly by the repetition of new slogans. Pre-propaganda creates feelings or instills stereotypes useful when the time for action comes. But even pre-propaganda fails unless there is a deep consonance, resembling Schwartz' resonating chord, between the emotionally tainted social beliefs and any new ideologies being promulgated. Propaganda itself plays on the already present assumptions and unconscious motivations of individuals and groups, relying on the universal mythologies of specific societies.

How, then, can public opinion be changed? How can a photograph operate as effective propaganda? Probably as pre-propaganda, for Ellul asserts that an informed opinion is vital to the subsequent galvanizing force of direct propaganda for immediate action. It is one of his most startling conclusions that, contrary to popular illusion, it is the *best* informed who are most susceptible to propaganda, not the least informed. Something cannot be created out of nothing. When sufficient numbers of individual Americans, for example, had absorbed the ongoing information supplied by the mass media, once the media had ceased simply forwarding government propaganda, the Vietnam war was no longer supportable. The change in opinion was slow, and hardly complete. Photographs of atrocities, coupled with live television coverage, helped by providing the incontrovertible evidence that the war was

neither simple, nor one-sided, nor without horrible fatalities to innocent civilians. Photographs of dead American soldiers returning home in body bags were certainly documents of an inescapable reality, if individuals could stand the painful emotion of looking at them.

Susan Sontag has written that the photographs of Auschwitz had a searing effect on her. People do not ordinarily enjoy painful spectacles, and such images turn people away, literally and physically. It is easier to repress or deny knowledge of horrors than to accept the guilt and powerlessness that accompany revelations of brutal inhumanities. Educators may prate about photographic literacy, but what is needed is an understanding of how any picture could miraculously transform painful information into coherent social action. For the obvious truth is that a single photograph, unaccompanied by verbal messages, cannot simultaneously contain both the image of the problem *and* the solution to the problem. A photograph, therefore, would seem to be able to pose the question, to imply a situation for which some other medium might be needed to provide the answer.

The inability of a single photograph to function as propaganda in modern terms leads to the potential conclusion that film (the motion picture) can operate on a higher level simply because it can incorporate aural messages, and because it is photography extended through time. This is perhaps why Béla Balázs, a noted film theorist, observed that it was only montage that could turn single images into truths or falsehoods.[8] Montage, or editing, provides a juxtaposition of materials—what Sergei Eisenstein called the collision of ideas—that permits an audience to draw complex conclusions, to grasp implications, or to be effectively jolted out of complacency and readied for new beliefs. In the case of positive propaganda like Marion Post Wolcott's harvest picture, cinematic editing may add little. Flashing iconic telegrams to the brain may be sufficient to resonate with stereotypical responses of patriotic variety. But to transform knee-jerk patriotism into patriotism based on humanitarianism requires not only long exposure to both words and images but words and images that can be accepted by individuals on an unconscious level, down in the depths of the psyche, where, as Freud said, absolute contradictions exist side by side.

Jacques Ellul believed that "propaganda can work only in the face of profound *immediacy.*"⁹ That is why photojournalists have always been identified with propagandistic efforts; they are identified with the relative instantaneity of the mass media. Photojournalists, then, are considered to rely upon propaganda's mass contagion, sometimes called the crowd effect, plus the fluctuating tensions associated with political decisions. In addition, their work implies a participation in group actions of large organizations like political parties or labor unions, where peers not only have the opportunity for interchanges of opinion but where opinion leaders can play their all-important roles.

This kind of relationship between photojournalism and politics is typified by the dirty tricks campaign during the Nixon election, when Edward Muskie, a front-running candidate for the presidency, was captured in a journalistic photograph as a grown man crying. Whatever the cause (exhaustion, attacks on his wife, false rumors, etc.), the immediate effect of an image of a grown man crying was astonishing. There was no doubt that a weeping male face was unacceptable to audiences of the 1960s, when the macho image of American presidents was still superordinate in this nation's psyche. Muskie's "crying face" was immediately distributed through the mass media, including newspapers and magazines, at perhaps the very moment when he was beginning to have some impact on potential voters. So deeply ingrained were the social beliefs that the myth of masculine imperviousness to emotion that it is extremely doubtful that a new series of published photographs, or even a television program demonstrating Muskie's undeniable manliness could have prevented his failure in the campaign. There was simply not enough time to reverse an image that had struck such a responsive chord in the mass audience.

Whatever the medium, film or photography, television or newspaper, all images are interpreted within the context of social beliefs. Since all photographs represent a paradoxical mix of information and persuasion, a condemnation of progaganda as being intrinsically evil is based on a misunderstanding of the nature of communication. Photographers dedicated to social reform or political change must recognize that they may only be able to contribute to the pre-propaganda phases. The political process is a sluggish behemoth; and once it turns in a direction and

gains momentum, it requires a stupendous effort to change its direction toward the achievement of humane goals. Unfortunately, it is all too easy for a single photograph of the "grown man crying" variety to play the responsible chord in the context of immediate political decisions. But long-term goals undoubtedly require continuous exposure of social wrongs and a vocabulary of change that can provide the basis of a new ideology. In that struggle, photography undoubtedly has much to contribute—if the photographer can develop not only patience but an uncanny sense of timing for the influential image.

NOTES

1. Quoted in William Stott, *Documentary Expression and Thirties America.* (New York: Oxford University Press, 1973). p. 30.
2. *Stott,* p. 23.
3. *Stott,* p. 14.
4. *Stott,* p. 62.
5. Jacques Ellul, *Propaganda: The Formation of Men's Attitudes.* (New York: Vintage Books, 1973). p. 25.
6. Stott, p. 62.
7. Tony Schwartz. *The Responsive Chord.* (Garden City: Doubleday, 1979).
8. See Béla Balázs, *Theory of Film: Character and Growth of a New Art.* (Dover, 1970).
9. Ellul, p. 266.

# CONTRIBUTORS

MARIA MORRIS HAMBOURG began studying Eugène Atget's work in 1976, during an internship in the Department of Photography at the Museum of Modern Art in New York City. From 1979 to 1983, following a year's research in France and the completion of her dissertation at Columbia University, Hambourg was a consultant for the definitive series of Atget exhibitions organized by the Museum of Modern Art. The fourth and final volume of her detailed essay on Atget is to be published in 1984. During the last year, Hambourg has written numerous articles for a variety of periodicals, including, *Revue du Louvre, Photographie,* and the *Times Literary Supplement,* London. In addition to working on several books, Hambourg will teach a course at Princeton University in the fall of 1984.

BILL JAY, an internationally known photographic historian and art critic, was born and raised in Berkshire, England. From 1969 to 1971 he was the director of the Institute of Contemporary Arts in London, and the editor-director of the English magazines *Album* and *Creative Photography.* He has worked at the International Museum of Photography at George Eastman House, the University of New Mexico Art Museum and the Bibliotheque Nationale in Paris. Since 1974 he has been on the faculty of Arizona State University in Tempe, where he is an associate professor and teaches the history of photography. Jay has authored over 200 articles and has delivered papers at symposia around the world. "The Photographer As Aggressor" is based on a reading in the past few years of more than 100 novels containing characterizations of photographers.

WILLIAM S. JOHNSON is editor of the annual *International Photography Index,* which began under his direction in 1977. He and his wife, who collaborate on many projects, are the editors of *Views,* published by the Photographic Resource Center in Boston. From 1979 to 1981 he was the curator of the W. Eugene Smith Archive at the Center for Creative Pho-

tography in Tucson; he has authored several books on Smith, including *W. Eugene Smith: Master of the Photographic Essay (1981)*. Johnson has organized numerous exhibitions on a wide-range of topics, many of which have traveled internationally. He has taught at Harvard University, The Museum of Fine Arts in Boston and the Visual Studies Workshop in Rochester, New York.

MARK JOHNSTONE is a photographer and critic living in Southern California. He is a contributing editor and critic for *Artweek* and the Los Angeles correspondent for *Afterimage*. Johnstone wrote the introduction to The Friends' publication *New Landscapes* (Untitled 24, 1981). He has been a visiting professor at the Photography Institute of Colorado College and has taught at other schools throughout the country. Johnstone served as content advisor for the twenty-program PBS series *The Photographic Vision*, produced through KOCE-TV in Huntington Beach, California. The essay on Larry Burrows is drawn from an ongoing investigation of the photographers who documented the Vietnam War.

ESTELLE JUSSIM is the author of *Visual Communication and the Graphic Arts* (1974), the biography of F. Holland Day, *Slave to Beauty* (1982), and *Frederick Remington, the Camera, and the Old West* (1983). In 1982 she received a Guggenheim Fellowship to pursue research on the career of Alvin Langdon Coburn. Jussim teaches the history of photography, film, graphic arts, visual communication and communication theory at Simmons College in Boston. She also serves on the Visiting Committee for the George Eastman House, as trustee for the Visual Studies Workshop and as critic for the *Boston Review*. The essay "Propaganda and Persuasion" is based in part on research for her forthcoming book, *Landscape as Photograph,* coauthored by Elizabeth Lindquist-Cock. It is to be published in 1984 by Yale University Press.

MAX KOZLOFF is a photographer, writer and art critic who has written a number of books on the history and criticism of contemporary art. His interest in photography developed in the late 1960s; the collection of his essays about the medium, *Photography and Fascination* (1979), was his first book devoted entirely to photographic issues. Kozloff was a con-

tributing editor for *Artforum* from 1963 to 1976 and served as its executive editor from 1974 to 1976. He has received numerous fellowships for his criticism, including a National Endowment for the Arts Critics' Fellowship (1972), a Guggenheim Fellowship (1969), a Pulitzer Award for Criticism (1962) and a Fulbright Fellowship (1962).

BEAUMONT NEWHALL is a prominent historian, curator, photographer, teacher and author who has produced numerous volumes on the history of photography. Among his most well-known books are *The History of Photography from 1839 to the Present Day* (1949, 1964, 1982), *The Daguerreotype in America* (1961, 1968, 1976) and *Latent Image: The Discovery of Photography* (1967, 1983). He worked at the Museum of Modern Art in New York City from 1935 to 1945, serving as the curator of photography beginning in 1940. He was curator of the International Museum of Photography at George Eastman House from 1948 to 1958, and its director from 1958 to 1971. Since 1971 Newhall has been a professor of art at the University of New Mexico in Albuquerque.

ALAN TRACHTENBERG teaches American Studies and English at Yale University, where he is chairman of the American Studies Program. Among his many books are *Brooklyn Bridge: Fact and Symbol* (1965), *The American Image: Photographs from the National Archives, 1860-1960* (1979), *America and Lewis Hine* (1977) and, most recently, *Incorporation of America; Culture and Society in the Gilded Age* (1982). He also edited a collection of writings, *Classic Essays on Photography* (1980). A 1983 recipient of a Guggenheim Fellowship, he is presently conducting research for a book on American photography.

ANN WILKES TUCKER is a curator, lecturer and historian whose writings on twentieth-century photography have been published in a great number of magazines and journals. She is presently the Gus and Lyndal Wortham Curator at the Museum of Fine Arts in Houston, where she has worked since 1976. Tucker has published many catalogues in conjunction with exhibitions at the museum, including a series highlighting the Target Collection of American Photography, which is housed at the Museum. Her book *The Woman's Eye* was published in 1973. She is currently

working on the exhibition and catalogue, *Unknown Territory: Ray K. Metzker.* A recipient of a 1983 Guggenheim Fellowship, she is preparing a major book on the history of the Photo League.

# THE FRIENDS OF PHOTOGRAPHY

The Friends of Photography, founded in 1967, is a not-for-profit membership organization with headquarters in Carmel, California. The programs of The Friends in publications, grants and awards to photographers, exhibitions, workshops and lectures are guided by a commitment to photography as a fine art, and to the discussion of photographic ideas through critical inquiry. The publications of The Friends, the primary benefit received by members of the organization, emphasize contemporary photography yet are also concerned with the criticism and history of the medium. They include a monthly newsletter, the journal, *Untitled,* and major photographic monographs. Membership is open to everyone. To receive an informational membership brochure, write to the Membership Coordinator, The Friends of Photography, Post Office Box 500, Carmel, California 93921.